BARNARD CASTLE & TEESDALE

THROUGH TIME

Paul Chrystal

AMBERLEY PUBLISHING

About the Author

Paul Chrystal is the author of the following titles in the Through Time series published in 2010: *Knaresborough; North York Moors; Tadcaster; Villages Around York; Richmond & Swaledale; Northallerton.* He is also author of the following titles in the series, published in 2011: *Hartlepool; In & Around York; Harrogate; York Places of Learning; Redcar, Marske & Saltburn; Vale of York.* And in 2012: *York Trade & Industry; In & Around Pocklington.*

Other books by Paul Chrystal: *A Children's History of Harrogate & Knaresborough, 2011; A to Z of Knaresborough History Revised Edn, 2011; Chocolate: The British Chocolate Industry, 2011; York and Its Confectionery Industry, 2012; Confectionery in Yorkshire – An Illustrated History, 2011; Cadbury & Fry – An Illustrated History, 2011; The Rowntree Family and York, 2012; A to Z of York History, 2012.*

As well as being an author and historian, Paul has spent over thirty years as a medical publisher and latterly as a bookseller; he lives near York.

To the memory of Ruby and Eric Chrystal, who first met in Barnard Castle.

First published 2012

Amberley Publishing
The Hill, Stroud
Gloucestershire, GL5 4EP

www.amberley-books.com

Copyright © Paul Chrystal, 2012

The right of Paul Chrystal to be identified as the Author of this work has been asserted in accordance with the Copyrights, Designs and Patents Act 1988.

ISBN 978 1 4456 0562 3

British Library Cataloguing in Publication Data.
A catalogue record for this book is available from the British Library.

Typeset in 9.5pt on 12pt Celeste.
Typesetting by Amberley Publishing.
Printed in the UK.

Introduction

'So splendid and special that the ultimate responsibility for them should be a national concern': this was the Council for British Archaeology talking about fifty-one exceptional British towns, of which Barnard Castle is one. Barnard Castle is indeed a splendid and special place, as is Teesdale – its beauty captured forever in the paintings of Cotman and Turner and in the poetry of Walter Scott:

> *O, Brignall banks are wild and fair, And Greta woods are green, And you may gather garlands there Would grace a summer queen.* 'Rokeby' 3, 394–7

Sentiments echoed some 200 years later by John Hillaby in his *Journey Through Britain*:

> *For me Teesdale was more beautiful than I could have imagined; certainly more strange and evocative than I could have foreseen.*

Many books have been published showing Barnard Castle and Teesdale in old photographs and on old postcards, but none so far show these in a 'now and then' or 'through time' context, as this book does. Old images are juxtaposed here with modern equivalents in full colour to demonstrate just how far, or not, things have changed in this historical and beautiful region of England. As such, it will provide residents, visitors and émigrés with a fascinating and nostalgic snapshot complemented by informative, incisive captions.

The book covers Barnard Castle, Middleton-in-Teesdale and a selection of Teesdale villages including Piercebridge, Gainford, Staindrop, Cotherstone, Romaldkirk and Mickleton. It features industries, streets, buildings, events and people in these places. In Barnard Castle, the story begins with the building of Bernard's Castle and proceeds through to the crucial bridging of the Tees with County Bridge and the establishment of the flax, carpet and tanning industries. In Middleton we focus on the agricultural and lead mining industries, and in the villages we visit picturesque greens, schools, inns and churches and the histories they have witnessed down the years.

We take in the visits of Charles Dickens and his resulting *Nicholas Nickleby*, and of Oliver Cromwell and Stan Laurel. The magnificent pile that is John and Josephine Bowes' museum and the County School are covered, as are the fine bridges at Greta and at Egglestone Abbey. The tributes paid to the region by Turner, Walter Scott and Cotman are rightly acknowledged.

Barnard Castle and Teesdale Through Time provides a unique picture of this unique region in black-and-white and colour photographs; it will be a lasting testament to its intriguing history and compelling scenery, one which can be dipped into or read in one go, and reread over time...

Paul Chrystal
November 2011

Acknowledgements

Thanks to Lancelot Nelson for providing many of the pictures featured in this book and to David Kelly for his IT assistance. Thanks too to Caroline Dougherty for the photograph on page 30 and for permission to make use of Ken Dougherty's meticulous research on aspects of the town and its inhabitants in earlier days. It is hoped that his work will be published more fully in a later publication. For some of the captions in the Barnard Castle chapter I have made use of Caroline's informative *Barnard Castle Trail*. Thanks also to the *Teesdale Mercury* for publishing my plea for images and information on the area and to Richard Laidler for the loan of his copy of *Sidetracks in Teesdale* by Stanley Cardwell. All of the modern photography is by the author.

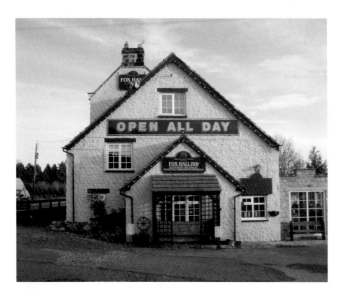

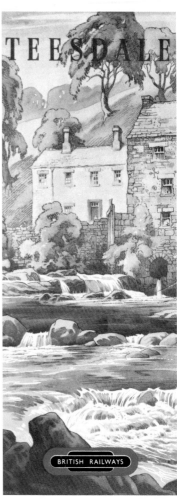

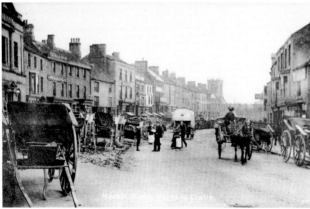

The pictures above are a 1960s British Railways brochure for Teesdale; the colourful Fox Hall Inn near West Layton on the A66, which tells you that you have arrived in Teesdale; a typical Barnard Castle Market Place scene from the 1920s.

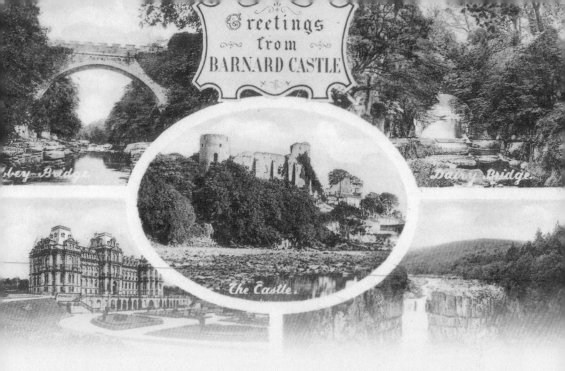

CHAPTER 1

Barnard Castle

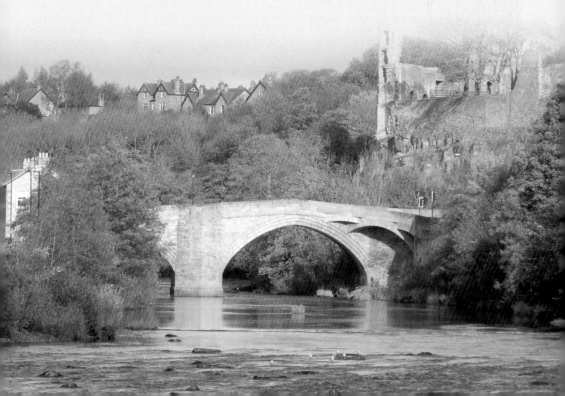

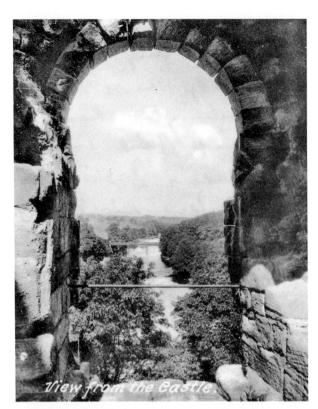

View from the Castle.

View from the Castle

This view takes in the 1893 pedestrianised Water Bridge, also known as the Deepdale Aqueduct or, more prosaically, the Tees Valley and Cleveland Water Board Aqueduct, which watered the Teesside towns of Stockton and Middlesbrough from reservoirs on the Rivers Lune and Balder. The Tees Viaduct is beyond that.

Bernard's Castle

The magnificent castle, commanding views of the valley below from its eighty-foot-high cliff. It was established on the authority of William Rufus by Bernard Baliol around 1130 and named after him; Guy, his father, had been given Gainford, Marwood and Middleton by William I for services rendered at the Conquest, and built a short-lived wooden fortification here. Substantial renovations were carried out by Richard, Earl of Gloucester, later Richard III. During the Rising of the North in 1569 it was besieged for eleven days by the rebel Nevilles and Percys; loyal George Bowes had 400 men, the rebels ten times that number. He held the fort for Elizabeth I, before surrendering it 'for want of provisions, upon honourable terms, being allowed to depart with arms, ammunition and baggage'. It fell into disrepair during the seventeenth century. The old image is a British Railways poster showing the Tees, castle and County Bridge painted by Jack Merriott.

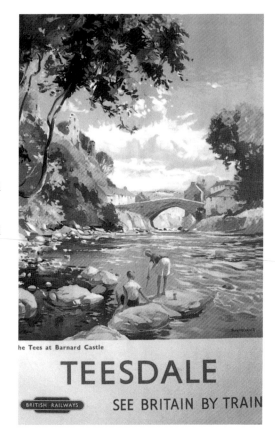

The Tees at Barnard Castle

TEESDALE

BRITISH RAILWAYS SEE BRITAIN BY TRAIN

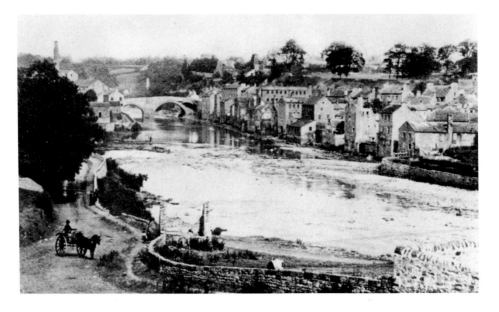

'The Busy Hum of the Loom'

The County Bridge and the chimney at Ullathorne's Mill are in the background, with the Bridgegate Mills on the far bank. These were all demolished around the time of the Second World War. Ullathorne's was one of the town's major employers. The large building right next to the bridge was Dunn's carpet factory. In 1821, records tell us that ninety-four local families relied on agriculture for their livelihoods while no less than 626 were dependent on factory work – mainly, but by no means exclusively, the manufacture of carpets. In 1836 there were over 400 carpet factory looms as well as those in the homes of piece workers. Top brands such as Kidderminster were manufactured here.

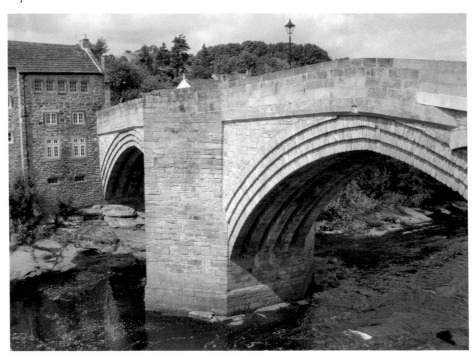

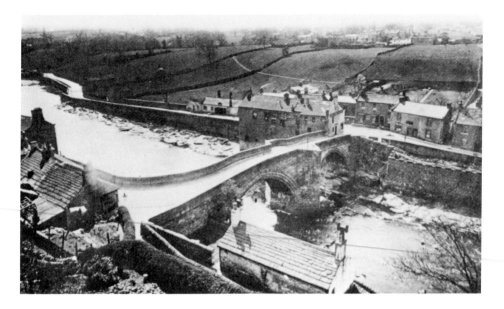

County Bridge

Looking back into Yorkshire from the castle, the White Swan is the first building on the other side in what was called Bridge End. This bridge was built on the site of a fourteenth-century three-arched crossing. Cuthbert Hilton allegedly performed illegal wedding ceremonies in the middle of the bridge in the seventeenth century, it being on the border between two bishoprics. Dunn's carpet factory was close by with its dye pits on the river. Raine's was another carpet factory with thirty looms and a loading bay on the river.

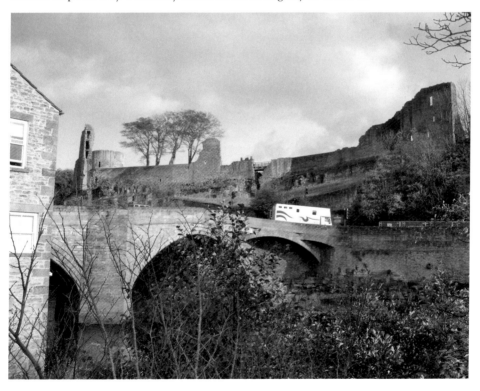

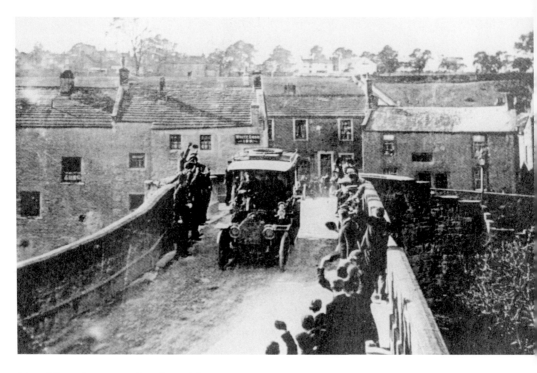

King Edward VII Crossing the Bridge
The king frequently came up to Teesdale for the shooting and here he is crossing a County Bridge lined with well-wishing townsfolk. The White Swan can be clearly seen in the background, its upper storey a weavers' workshop. The traffic refuge on the right housed a small chapel at one time.

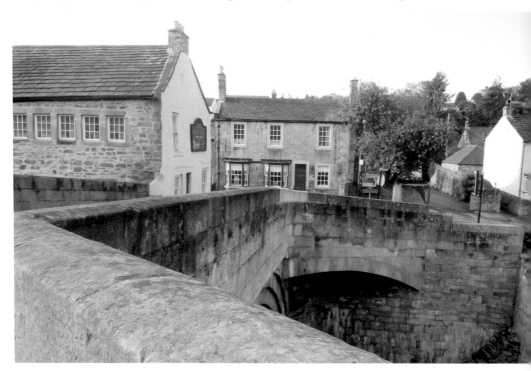

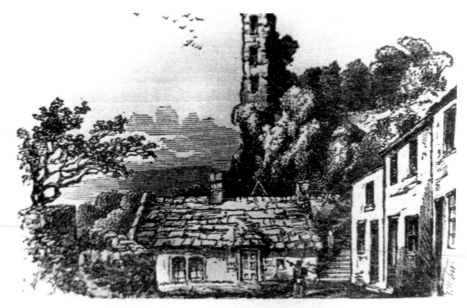

BARNARD CASTLE, FROM BRIDGEGATE.

The Toll House

The toll house for County Bridge depicted here was the second such building – the first having been washed away in the 1771 Great Flood. You can just see the hatch to the right of the door, through which travellers would pass their money.

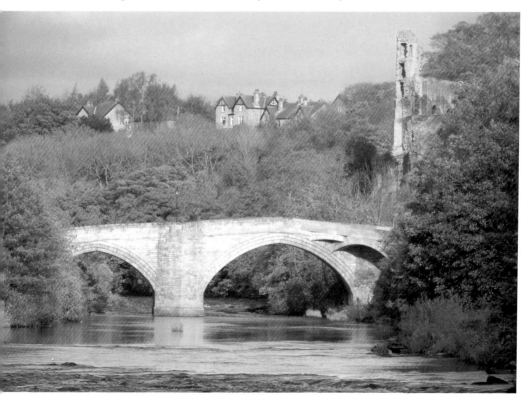

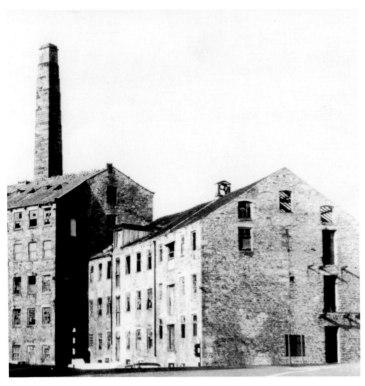

Ullathorne's Flax Mill
Part of the Bridge
End Mills complex,
this was Ullathorne &
Langstaff's; the picture
dates from 1760, and
with 400 workers at its
peak this was the town's
biggest employer for
many years. Shoe thread,
rope and twine were the
main products made
from flax imported
from Ireland. The
factory closed in 1931
and was demolished
in 1976. Before flax the
town had a significant
woollen industry
from the fourteenth
century. The modern
photograph shows some
of the converted factory
buildings today.

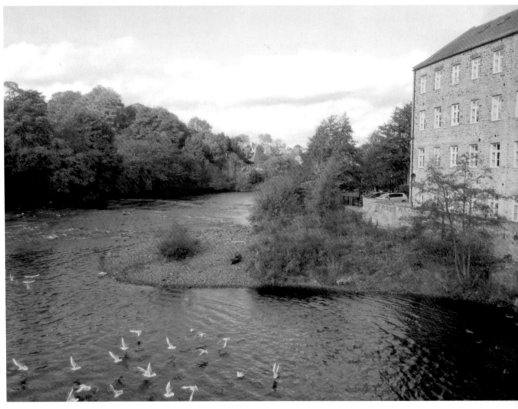

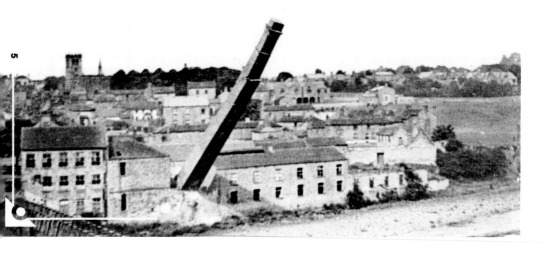

J. Monkhouse's Thorngate Factory

The last day for the chimney at the woollen factory in 1933. The factory specialised in protective clothing for the Admiralty and the steel industry. The weavers' houses were converted into Mill Court private residences in 1986 by Teesdale Buildings Preservation Trust. At the demolition local scouts waded into the river to salvage bricks later used in the building of their new hut in Dawson Road. Thorngate Mill was, from 1935, the home of the North of England Chamois Leather Factory – manufacturer of gloves and a tannery. The new picture looks down The Bank into Thorngate, site of much of the town's industry.

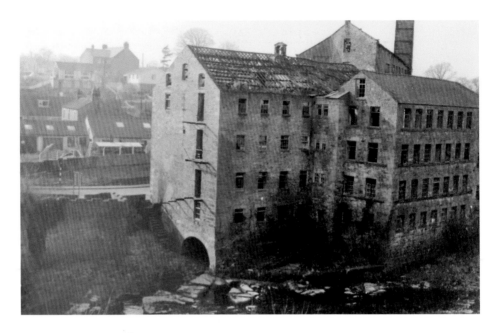

Ullathorne's Flax Mill

Now in a somewhat dilapidated state, Ullathorne & Langstaff had, at its peak, branches in Paris, Melbourne, Brisbane and Wellington, as well as in Barnard Castle. Thread was produced for saddlers and cobblers and for mattresses and salmon fishing nets. The bell visible on the roof summoned workers at 5.55 a.m. each morning; latecomers were docked two hours pay. GlaxoSmithKline's factory is the modern face of industry in the town. GSK is one of the world's leading pharmaceutical companies and came to the town in the 1940s to manufacture penicillin.

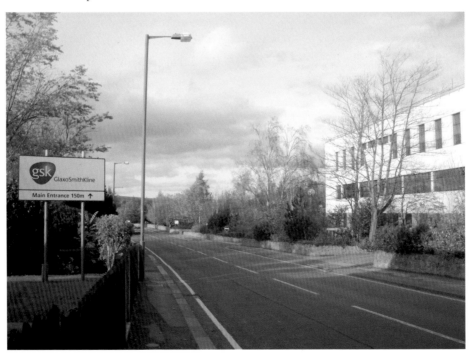

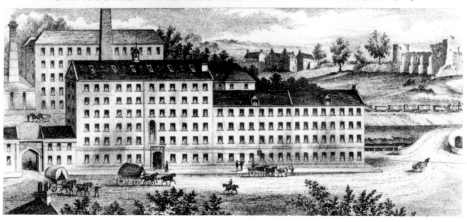

FILS & ALÉNES
POUR
CORDONNERIE & SELLERIE
FOURNITURES GÉNÉRALES POUR CHAUSSURES

Fils & Alénes

An advertisement produced by the Paris office of Ullathorne & Langstaff promoting 'threads and awls for shoemakers and saddlers and general accoutrements for footwear'. The picture of the Barnard Castle factory is somewhat idealised, with exaggerated factory buildings and a very convenient railway siding. The quotation on page 8 is from the *Teesdale Mercury* in 1891 in a report on the new, post-industrial Barnard Castle: 'the Barnard Castle of today is, I am sure, to be preferred to what it was when the busy hum of the mill was in full swing'. Today's photograph shows the converted factory buildings.

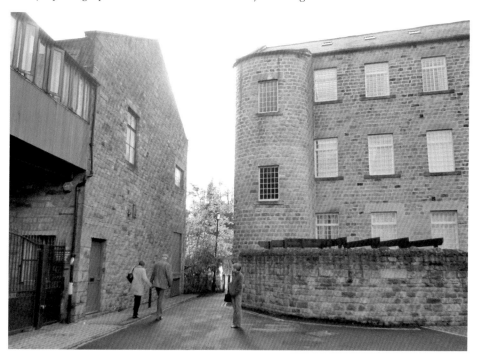

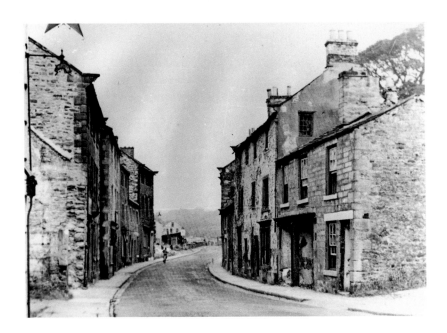

Bridgegate, 1962

Or Briggate; the population in this industrial slum area in the mid-nineteenth century was 4,351, all sharing five pumps for running water and sanitation. The buildings to the left were demolished to widen the road as it leads round to County Bridge. The rapid decline of the carpet industry began in the mid nineteenth century hastened by two devastating cholera epidemics in 1847 and 1849 (145 people died in 1849 alone, the majority residents of Briggate and Thorngate). Barnard Castle had won a reputation as a 'plague town'; representatives were loathe to visit and the workforces were decimated. Moreover, the late arrival of the railways here in 1860 made the town uncompetitive and isolated for many years and the introduction of linoleum in 1863 hit the bottom end of the local market. The Blue Bell public house is in the new photograph on the corner of Bridgegate and Thorngate.

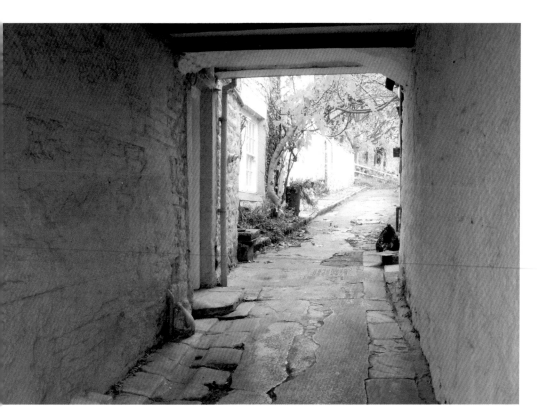

Barnard Castle Co-op and Ranter's Yard

Bridgegate in around 1925. The Co-op here opened in 1862 in what was its third location. The new photograph shows a typical alleyway off The Bank today. There were a number of alleyways off The Bank: the one in between Nos 24 and 26 not only accommodated houses but was also the site of a theatre and two Methodist chapels (one a Primitive) winning it the nickname Ranters' Yard. Interesting occupants of properties on The Bank over the years include Thompsons Clog and Patten-making factory at No. 43; the Shoulder of Mutton at No. 34; carpet weavers at No. 18 and No. 54 has been at various times dyer, draper, butcher, boot maker and tailor.

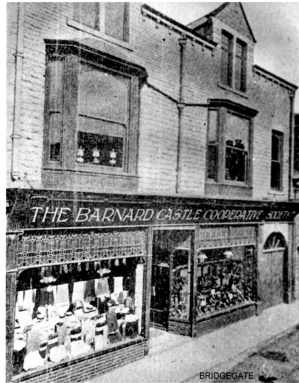

BRIDGEGATE

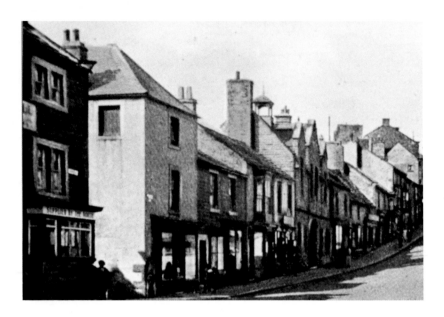

The Bank

At the junction of Bridgegate and Thorngate, with the 1901 Church Mission in the centre of the picture. The Blue Bell Hotel is on the near left and, as at the Market Cross at the top of the hill, the junction here was widened, in this case by demolishing the white building on the opposite corner. The modern photograph looks down The Bank from the Market Cross with the Old Well public house on the right (there is an old well in the cellar), which was formerly named the Railway Hotel – the railway and its station is nowhere near, so perhaps it was because a number of navvies working on the railway lived here? Before that it was the Ship Inn. In the 1850s the railway offered shower and body baths, hot and cold at 2*s* 6*d* a session 'fitted up in an elegant and commodious manner'.

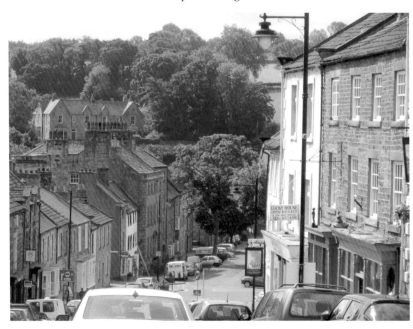

Blagrave's House or Broadgates

Named after a seventeenth-century owner, this, the oldest surviving residence in Barnard Castle, is otherwise known as Cromwell's House on account of a visit he made on 24 October 1648. It was given by Richard III to Joan Forest wife to Miles Forest, Keeper of the Kings Wardrobe, who with John Dighton is said to have disposed of the two young princes. Blagrave's has served many purposes, including coal merchant, shoemaker, an inn and a brewery – the Boar's Head; a secret meeting place for early Methodists; the Old House of Mystery, a museum, as shown here in the old picture; the Cromwell Restaurant and Kavanagh's Rope Makers. The stone statues on the wall represent musicians.

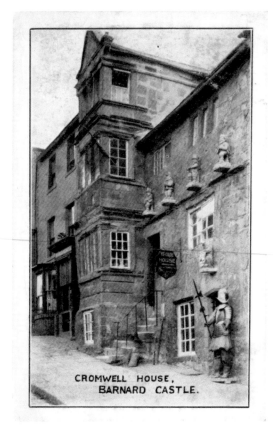

CROMWELL HOUSE,
BARNARD CASTLE.

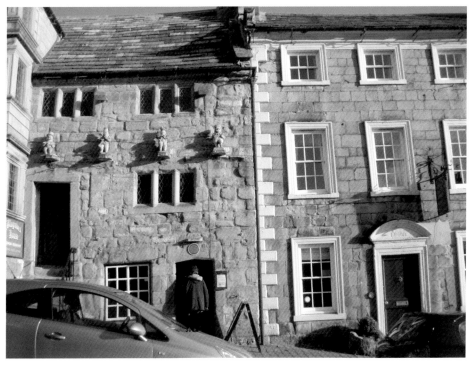

19

Amen Corner

Demolished to widen the Newgate–Market Cross junction in 1932. The shop to the right was Thomas Humphrey's, clockmaker, immortalised in Charles Dickens' *Master Humphrey's Clock* – a weekly periodical edited and written by Dickens and published from 4 April 1840 to 4 December 1841. It included short stories followed by *The Old Curiosity Shop* and *Barnaby Rudge*. Dickens met Humphreys in 1838 when staying at the King's Head researching local boarding schools for *Nicholas Nickleby*. Humphreys moved to the Horse Market opposite the King's Head in 1842. The fruits of Dickens' research was the fictional Dotheboys Hall: in chapter three we learn from the nineteenth century equivalent of the *Times Educational Supplement*: 'EDUCATION – At Mr Wackford Squeers's Academy, Dotheboys Hall, at the delightful village of Dotheboys, near Greta Bridge in Yorkshire, Youth are boarded, clothed, booked, furnished with pocket-money, provided with all necessaries, instructed in all languages living and dead, mathematics, orthography, geometry, astronomy, trigonometry, the use of the globes, algebra, single stick (if required), writing, arithmetic, fortification, and every other branch of classical literature. Terms, twenty guineas per annum. No extras, no vacations, and diet unparalleled. Mr Squeers is in town, and attends daily, from one till four, at the Saracen's Head, Snow Hill. N.B. An able assistant wanted. Annual salary 5 pounds. A Master of Arts would be preferred.'

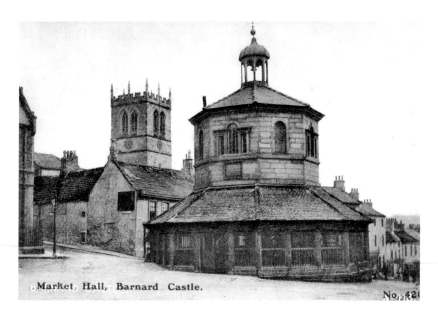

Market Hall, Barnard Castle. No. 42(

Market Cross Around 1918

Variously known as Buttermarket, or, as on this card, Market Hall. The white building in front of St Mary's church is Amen Corner with Finlay's shop, which has since been demolished. The corner of Backhouse Bank, built 1877 and replacing the Queen's Head, is just in shot on the left. This card is from when the Cross was used as a fire station (see the bell in the cupola). St Mary's was established by the Baliol family. Dotheby's Hall (see page 20) was based on the Bowes Boys Academy. The building can still be seen in Bowes. One proprietor of the school, William Shaw, was the model for Wackford Squeers. Shaw's grave is in the local churchyard.

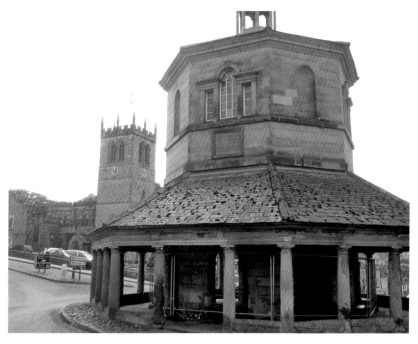

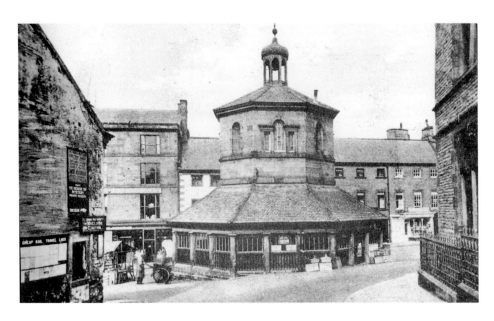

Market Cross from Newgate

The central part dates from 1774 and comprises a piazza enclosed first by iron railings, which are visible here, and then glass and timber panels. Amen Corner is prominent on the left with advertisements and timetables for LNER (including cheap bar), Ye House of Mystery (Blagrave's), and the Wycliffe Cinema. It was built by Thomas Breaks – a prominent wool merchant – in 1747, originally to protect women selling their dairy produce, and incongruously, in the middle of the road, much to the chagrin of generations of horse and cart and lorry drivers. In the modern photograph the white building behind the Cross was once the Junior Liberal Club.

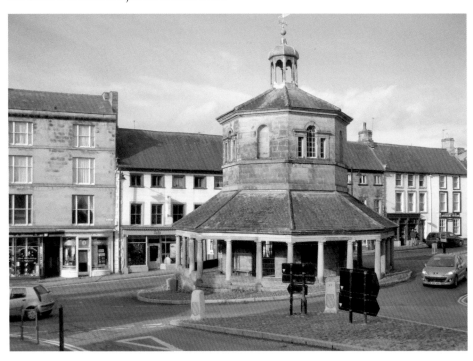

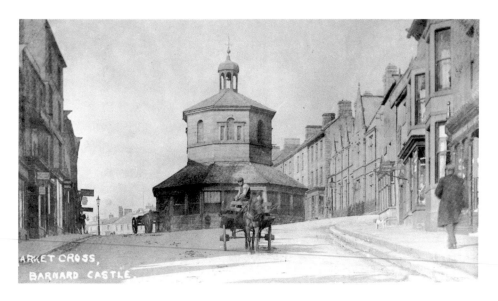

Market Cross from The Bank

Uses have been many and various and include: a butter market, a look-out for vigilantes, live poultry and rabbit sales, a courthouse and lock-up, a town hall (after the Shambles was demolished), a surveyor's and a fire station. The cupola was renovated in 1999, although the two musket holes from 1804 in the weather vane have been left intact. These were the result of a shooting competition from outside the Turk's Head between a soldier called Taylor of the Teesdale Legion of Volunteers, and Cruddas, the Earl of Strathmore's gamekeeper. Shops on the right were Finlay's grocers and Spratts dealers (patent dog cakes and bird seeds) and R. Watson, formerly Thomas Humphrey's shop. The horse here would have no problem going down The Bank, but to get up it would have to zigzag across the street to beat the gradient.

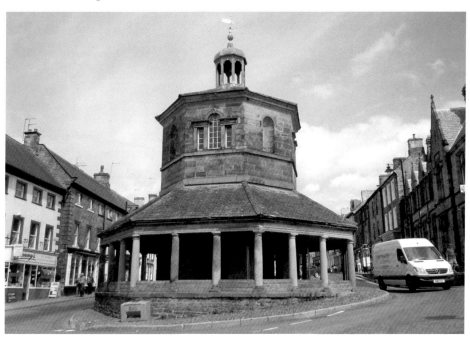

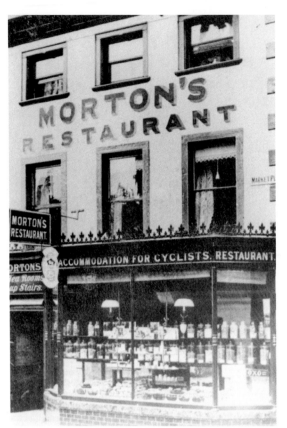

Morton's Restaurant

In Market Place next to the Cross, for many years the town's largest restaurant ran a thriving outdoor catering business as well. Clients included the North East County School, Streatlam Castle and Lartington Hall. Market Place demonstrates the rich diversity of shops and businesses that have traded in Barnard Castle down the years: No. 25 was a girls' school run by Miss Merrick around 1890; the *Teesdale Mercury* ('the voice of Teesdale' since 1854) at No. 24 maintains a tradition of publishing on the premises following in the footsteps of a former printer, a bookseller and a circulating library here; No. 37 has at various times been a butcher (around 1667), painter, toy shop, decorator and a grocer.

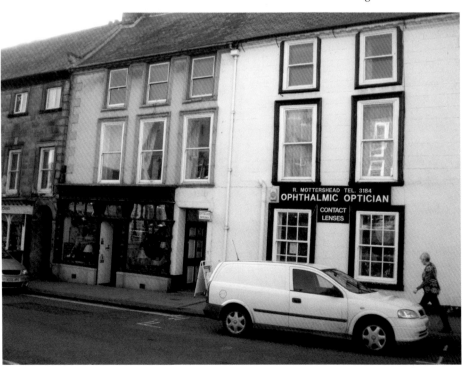

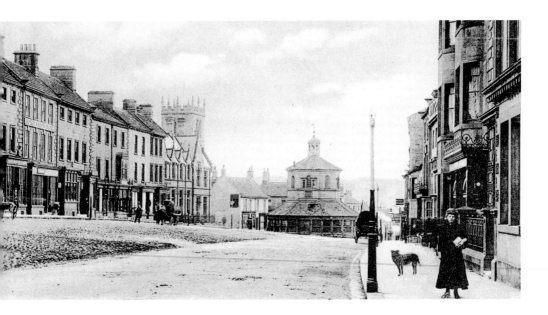

Market Place

Teesdale House can be seen on the left with Howson & Rea. Behind this and the other buildings on the left were the twelfth-century burgesses' plots – long backyards reaching to Queen Street (formerly Back Lane). St Mary's church is in the background. Ken Dougherty's research tells us that in 1879, No. 7 was J. E. Davis, bookseller's, No. 5 was Elizabeth Humphreys, silversmith, and No. 3 was T. Bell, ironmonger. In addition to its bookselling, No. 7 was home to the following businesses from 1828 to 1938: stationer, gunsmith, saddler, architect, fancy goods, cycle agent, Teesdale Electrical Engineering Co., and boot and shoe dealer. In contrast, No. 3 was much more stable, being an ironmonger's in the Bell family from 1851 to 1950.

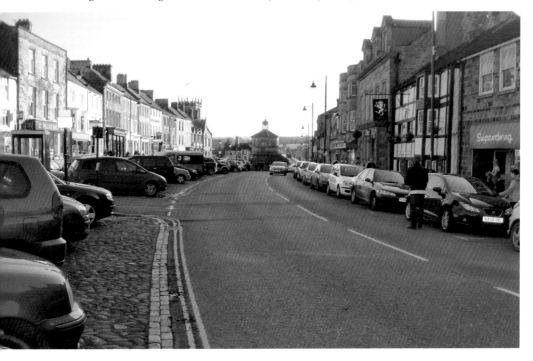

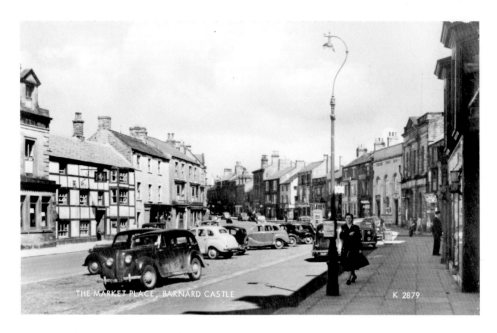

1950s Market Place and Daniel Defoe

The horses are long gone, superseded by the motor car and lorry. Daniel Defoe, when he reached Barnard Castle in the 1720s, was particularly taken by the town's equine population, recording in his *A Tour Through the Whole Island of Great Britain*, ''Tis an ancient town, and pretty well built, but not large; the manufacture of yarn stockings continues thus far , but not much farther; but the jockeys multiply that way; and here we saw some very fine horses indeed; but they wanted no goodness, so they wanted no price, being valued for the stallion they came of, and the merit of the breed'. Prominent in both photographs is the Golden Lion.

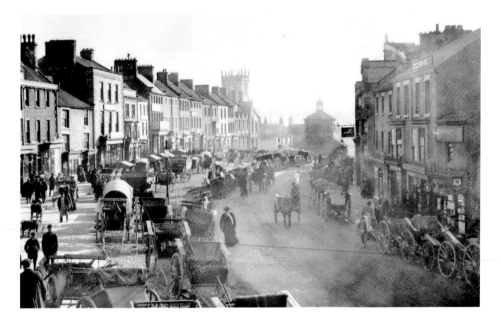

Market Place and Horse Market

The protruding inn sign on the right is for the Golden Lion and the six-windowed building centre right is Teesdale House with Hall Street through the archway nearer to the camera. The magistrates' courts and police station were down here on Back Lane, hence the local phrase 'a trip up Hall Street' meaning a visit to the local jail. Next to this was Hall's chemist and druggist. The new picture shows the alleyway that is Hall Street leading to Queen Street, the point at which Market Place and Horse Market meet.

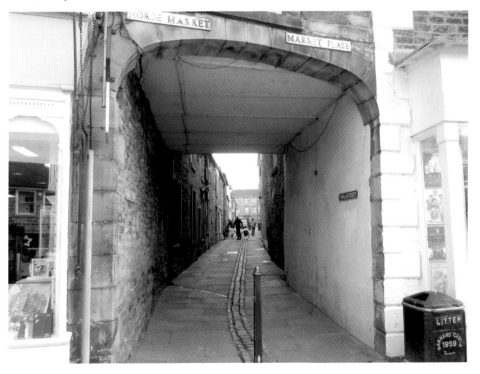

COAL ROAD LEVEL CROSSING
BARNARD CASTLE

The Railways and the Witham Testimonial

After much procrastination and opposition from local landowners – notably the Earl of Darlington – the railway finally arrived at Barnard Castle in 1856, with the first station sited near where the Montalbo Hotel is now. This became a goods station on the opening of a new station, where GlaxoSmithKline's car park is now. The railways brought with them much tourism and Witham Hall, built in 1854 in memory of H. T. M. Witham of Lartington Hall, would have benefitted from the influx of visitors (see page 29).

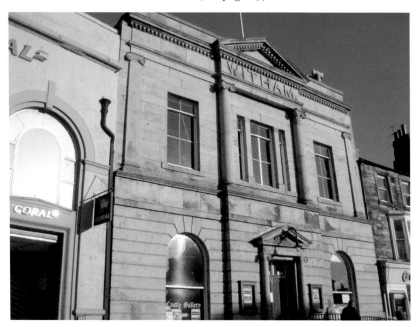

Teesdale Handy Guide
Local advertisements typical of those published in the *Teesdale* volume of the *Handy Guide Series*, London, 1921 (see page 72). Harry Ward owned a stationery shop at 21 Horse Market from 1905 to 1925. The modern photograph shows the blue plaque on Witham Hall. The 1935 official guide *A Modern Town with Great Historical Associations* describes it as follows:

Here the Mechanics' Institution has its quarters; including a reading room and a lending library.Here also is the Barnard Castle Dispensary founded in 1835 and still performing a useful service to the sick poor of the town. On the second floor is a lecture room, and at the rear is a spacious music hall used for concerts and public gatherings. Here the Barnard Castle Choral Society, founded in 1856, gives its annual concerts. On Market Days (Wednesday) the Hall is used as the Market Hall for the sale of Farm Produce.

THIS BUILDING WAS ERECTED BY PUBLIC SUBSCRIPTION AS A TESTIMONIAL TO H.T.M.WITHAM ESQ.OF LARTINGTON HALL AFTER HIS DEATH IN 1844. IT HOUSED MEDICAL AND EDUCATIONAL FACILITIES WHICH MR WITHAM AS A PUBLIC BENEFACTOR HAD WORKED TO PROVIDE FOR THE TOWN AND DISTRICT. HE WAS AN EMINENT GEOLOGIST AND WAS A FOUNDER MEMBER OF THE ROYAL GEOLOGICAL SOCIETY.

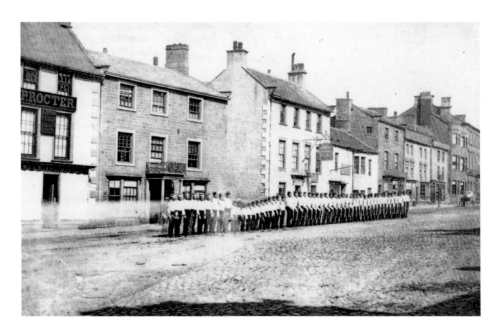

The Militia

The Third Regiment of Militia was raised in 1759 by the Earl of Darlington to become the Durham Light Infantry in 1887. Barnard Castle was the headquarters of the 3rd Battalion, and their 1864 barracks were sold to the local council in 1930 and replaced by housing. The 1st South Durham Militia was stationed here from 1855 to 1881. In 1914 the 3rd (Reserve) Battalion was at Newcastle as a training unit, and mobilised to South Shields; the 4th (Extra Reserve) Battalion was at Barnard Castle in 1914 then mobilised to the Tyne defences and Seaham Harbour in September 1915. Procter's was Harrison Procter's 'chymist, druggist and grocer'. The new photograph shows Market Place looking towards Horse Market.

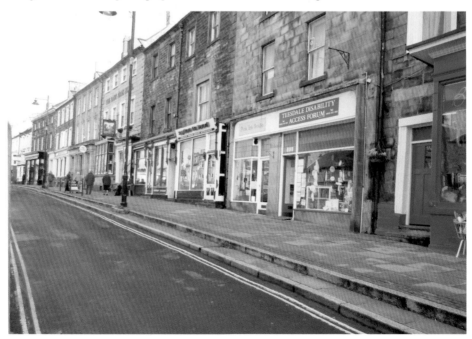

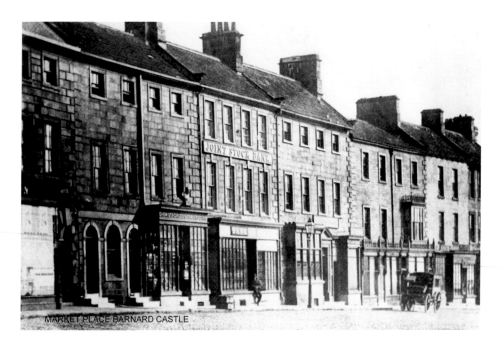

MARKET PLACE BARNARD CASTLE

Bull Baiting in Market Place

Although the upper windows have, for the most part, survived, the lower doorways and windows have been converted. The Joint Stock Bank (now HSBC) was built on the site of Thomas Brunskill's confectioners in 1828. To the right of The Bank is the Raby Arms while to the left is a chemist and druggist, another chemist and then the corner of the County School for Girls. Bull baiting took place outside the Raby Arms. Indeed, the local saying 'Lartington for frogs and Barney Castle for butcher's dogs' attests to the town's reputation for bull baiting.

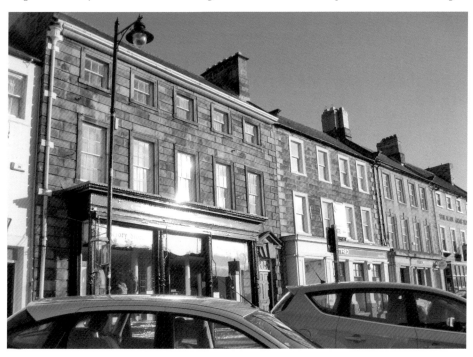

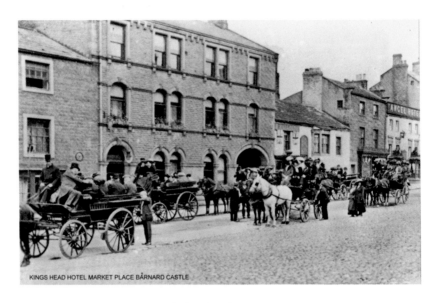

KINGS HEAD HOTEL MARKET PLACE BARNARD CASTLE

The King's Head Hotel: 'Good Ale There'

The hotel is on the right, seen around 1930, with the Red Lion next door. The King's Head extension to the left was built around 1800 on the site of the former Rose & Crown. The public conveniences opposite, shielded by a privet hedge, were built in 1913 despite objectors from the King's Head, who argued 'public urinals have been found to be a public nuisance' and, anyway, people could always go up the yards and alleys of public houses. Dickens, having stayed there with Hablot K. Brown ('Phiz'), did the King's Head no harm at all when he referenced the hotel in *Nicholas Nickleby* in a letter from Newman Noggs to Nickleby: 'There is good ale at the King's Head. Say you know me and I am sure they will not charge you for it. You may say Mr Noggs there, for I was a gentleman then; I was indeed'.

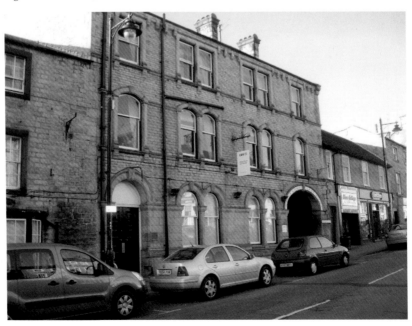

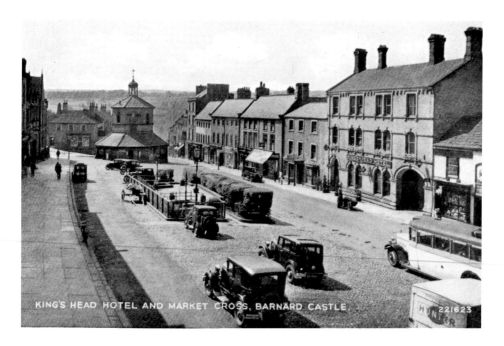

KING'S HEAD HOTEL AND MARKET CROSS, BARNARD CASTLE

Cock Fighting at the Red Lion

The Red Lion was notorious for its cockfighting. The archway of the King's Head next door can be seen, through which access to the castle could be gained via Castle Wynd and Town Gate, long demolished. The Red Lion suffered the same fate in the early 1960s. Between 1828 and 1934 the number of pubs and inns in the town remained around twenty-five with a high of twenty-nine in 1851 and a low of twenty in 1934.

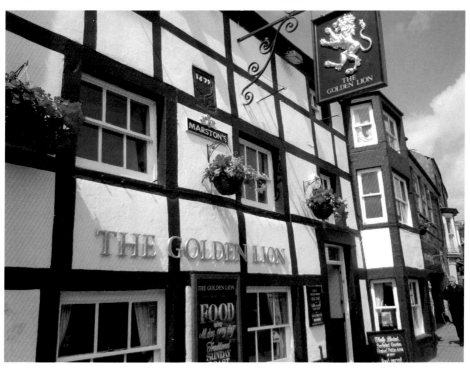

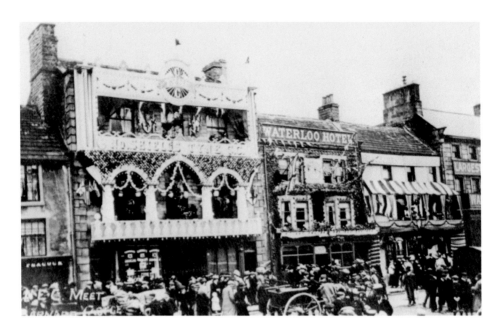

North Eastern Cyclists' Meet

Cycling was extremely popular in the early years of the twentieth century and it was customary for meet organisers to decorate the venues at which they congregated. Here we see Milner's Temperance Hotel, the Waterloo and the Turk's Head all decked out by North Shields Tyne Cycling Club and the Brunswick Cycling Club – two of the leading clubs in 1909. The first North Eastern Cyclists' Meet was held in 1886 and annually on Spring Bank Holiday ever since.

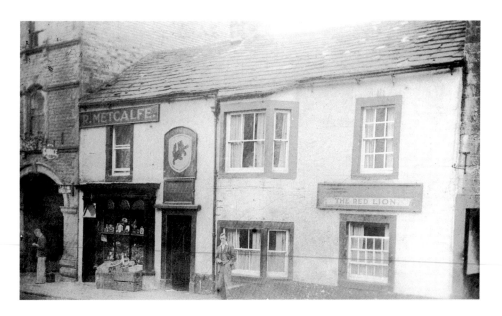

The Red Lion

One of many public houses in Market Place alone, which included the Raby Arms, The Greyhound, Turk's Head, Golden Lion, Half Moon, New Waterloo, Waterloo, Rose & Crown, King's Head, and the Angel. Market Place was originally called Great Market to distinguish it from Horse Market and from the Galgate livestock markets. *The Granger Report* of 1850 gives us a vivid picture of life in the yards of Barnard Castle: 'In Old Priory-yard, a cul de sac, There are 15 tenements occupied by 64 persons and, in one instance only, there are 6 persons living in a single room. A large cesspool in the centre of this yard is surrounded by houses; the soil, it is stated, has not been removed for years, and there is but one privy to 15 houses'.

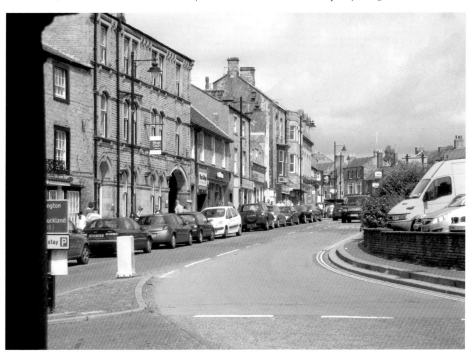

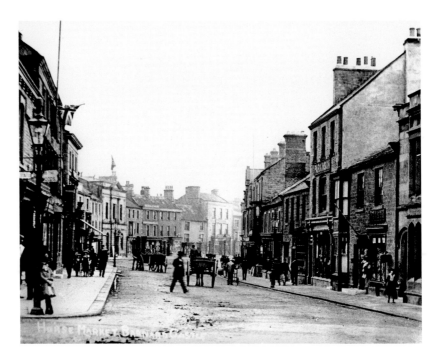

Horse Market, 1907

On the corner of Galgate, the shop nearest to us on the left was J. G. Johnson's, butcher's, which still boasts some impressive tiling under the windows. The white sign directs us to the railway station while the one behind it rather excitingly takes us 'to the woods'. Parkinson's is on the right with Walker's hardware nearer to the camera. The grand Witham Hall (see pages 28 and 29) is on the left. At No. 9, Joseph Hall's boot makers since 1835, Mrs Anderson in 1934 could offer 'chiropody under the personal supervision of Mr Watson'.

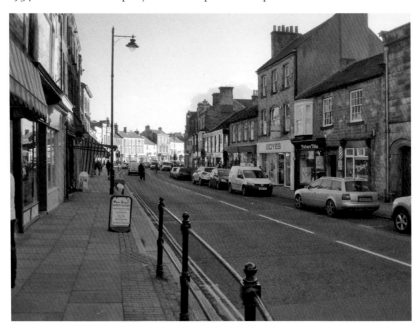

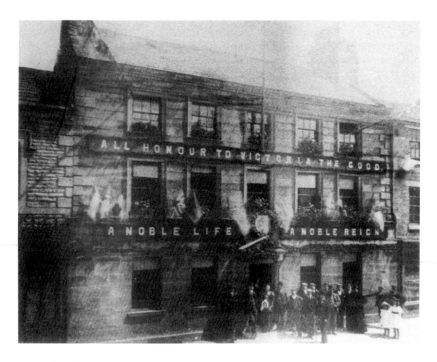

Long Live the Queen

Framed in a floral tribute above the door, this is the Workingmen's Conservative Club in Horse Market all decked out to celebrate Victoria's Diamond Jubilee in 1897. The workhouse inmates enjoyed a special meal and casuals on outdoor relief were given an extra shilling! Where Boyes is now (see page 38) Jessamine Eales and Jessie Colt once ran their straw bonnet manufacturing and sales. You could also book your passage here from Liverpool to New York or Boston on a Royal Mail steamer with the Cunard Shipping Company through agent John Parkinson.

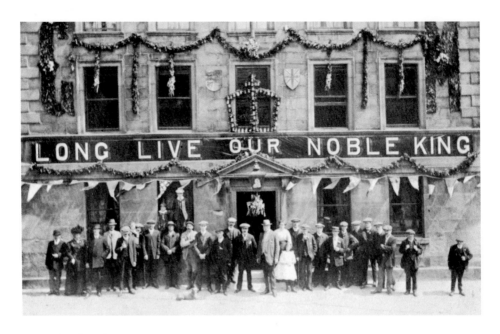

Long Live the King

Once again outside the Workingmen's Conservative Club in Horse Market. The building was once the town's post office and the occasion this time was the coronation of King George V and Queen Mary on 22 June 1911, with decorations courtesy of the Conservative Club and the Women's Unionist Association. Events included a peal of bells, horse parade, church service and lunch at the Turk's Head, along with a procession and children's sports. In the 1920s, Rileys, on the right here, was the home of Mrs Wiseman's artificial teeth shop.

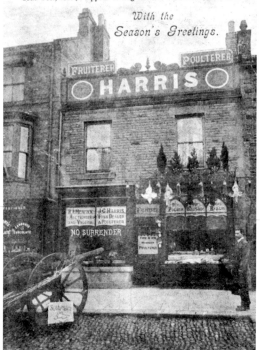

11th May, 1904 : Police Court Proceedings ; Case Dismissed.
20th Dec., 1905 ; Appeal to High Court ; Dismissed with Costs.

'No Surrender Harris'

Perhaps the 1905 report in the *Newcastle Chronicle* puts it best: ' A Barnard Castle tradesman was confronted with a blood-curling [sic] spectacle on drawing his blind one morning recently. He had erected a new window in his premises without the sanction of the Urban Authority.' Someone had mischievously moved the Boer War gun from Galgate to aim at the defiant George Harris' window in Horse Market and put up a notice demanding he 'surrender or die'. Harris responded with 'no surrender' and was known as 'No surrender Harris' ever after. The contemporary picture shows the fine tiling under Johnson's window – see page 40.

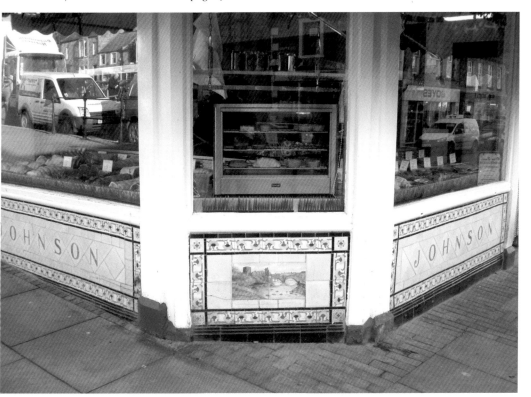

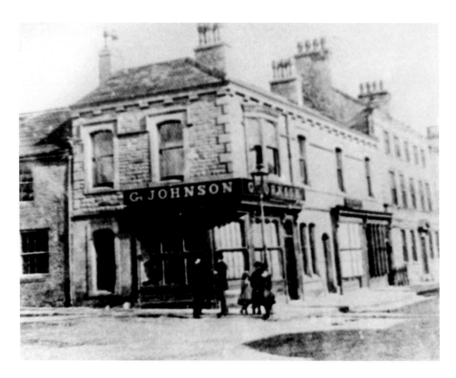

Johnson's Butcher

A butcher's since 1870 when J. G. Johnson bought the building and refurbished it. Always a focal point in the town, the corner has had various names down the years, which reflect the ownership of the shop – notably 'Young's Corner' and 'Tarn's Corner'. Johnson's rebuild featured some very impressive coloured tiling on the façade pictured on the previous page.

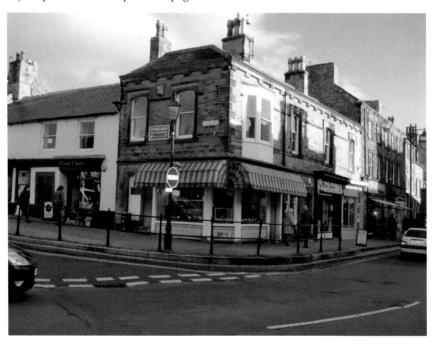

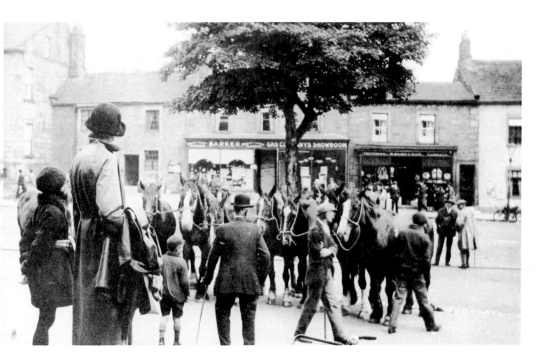

Horse Fair in Galgate

The regular horse fair was held here in Galgate until 1939. Barker's the plumber and gas engineer's can be seen over the road with W. Burn, fruiterer and florist, next door. Galgate was originally Gallowgate and this, along with nearby Hangslave, tell us where public hangings took place. Until 1922 the street also hosted a fortnightly cattle market.

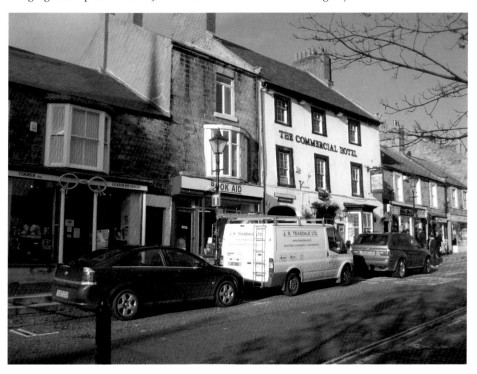

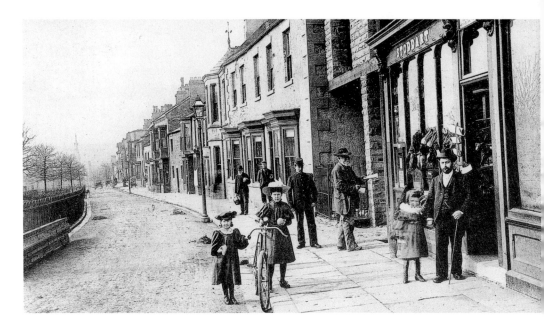

Galgate

Postman and post office can be seen here around 1895 with the spire of the recently built Holy Trinity Methodist church just visible in the background. For a while Galgate was *the* place to live. The half-built building next to Stoddart's became the premises of E. A. Metcalfe, photographer; then, from 1925, Dalston Cycles. Galgate roughly follows Roman Dere Street, which ran from York to Corbridge.

Milner's at No. 10 Galgate

Some interesting advertisements at this general dealer's: Cerebos salt and Bovril in the window; on the wall, the Bryant & May matches advertisement is sandwiched in between notices exhorting locals to support home industries and employ British labour. Van Houten – Dutch chocolate and cocoa manufacturers – were, at the beginning of the twentieth century, significant competition for British firms like Fry's, Cadbury's and Rowntree's. Along with a number of French companies they were extremely successful importers; Van Houten was particularly important because the founder, Coenraad van Houten, invented the eponymous hydraulic press, which revolutionised chocolate production. The drinking fountain in the new photograph was installed in 1873 and shared by animals and people.

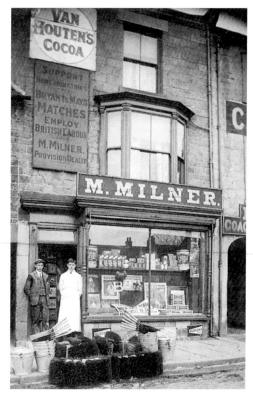

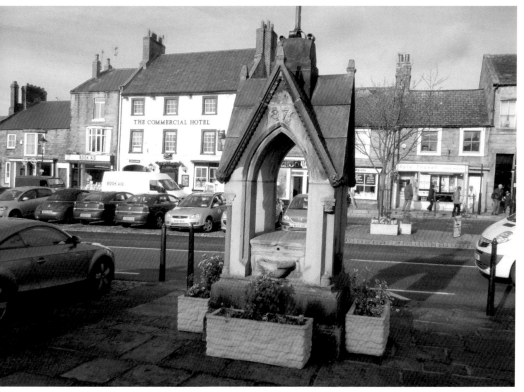

43

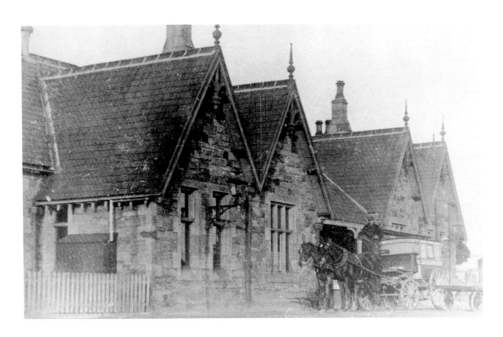

Barnard Castle Station and Saltburn-by-the-Sea

This is the second station to serve Barnard Castle: the photograph shows Smith's horse-drawn taxi service for the King's Head Hotel around 1900. It is around half a mile to the north of the original station in Galgate and was built to cater for the 1861 extension of the 1856 Darlington to Barnard Castle line from Stainmore to Tebay. The fine portico of the old station was removed intact to Saltburn-by-the Sea to honour Prince Albert, and it remains there to this day as the modern picture shows.

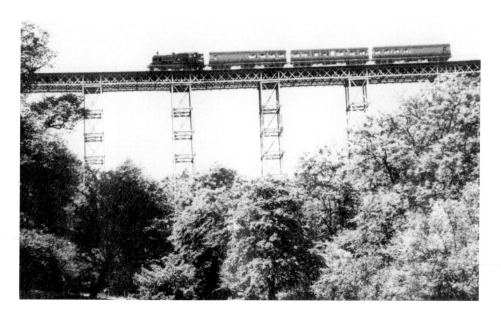

The Tees Viaduct

This majestic bridge carried the South Durham & Lancashire Union Railway line from Barnard Castle to Tebay and Penrith, and was opened on 4 July 1861. In 1868 the Middleton to Barnard Castle line shared the viaduct. Thomas Bouch designed it – he was also the designer of the ill-fated Tay Bridge. The main use of the Tees Viaduct was for trains carrying iron ore from Furness to the emerging steel industry in Middlesbrough, and coke the other way. It was 732 feet long and 132 feet high, with five spans each 120 feet long, and was closed in 1965 and demolished in 1972. The modern photographs here and on page 46 are of the River Tees at Egglestone Abbey.

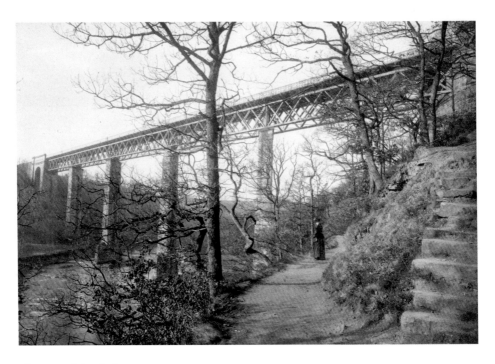

The Deepdale Viaduct

Another Bouch design, this iron construction was also known as Cat Castle Viaduct. It was built in 1858, is 740 feet long and 161 feet high. The line to Tebay crosses Stainmore at a height of 1,370 feet making it the highest passenger line in England at the time. It closed in 1963 and was demolished in 1964.

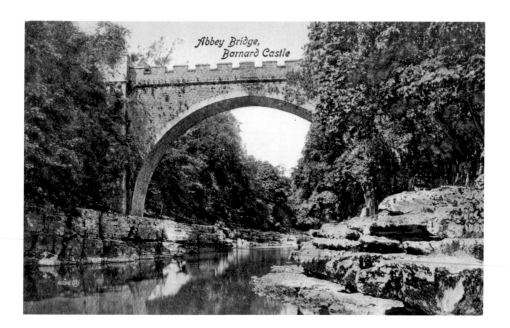

Abbey Bridge

J. B. S. Morritt of Rokeby Hall was the benefactor who provided this sixty-foot-high road crossing. It opened in 1773 with a Masonic ceremony and became such a busy route into town that the post office was persuaded to move from Bridgegate to Newgate, *en route* from the bridge. Coleridge came in 1779 and Sir Walter Scott in 1791 remarking on its 'walls with battlements' and that the Tees was 'condemned to mine a channel'd way/o'er solid sheets of marble grey', referring to the Tees marble (limestone slabs) that was mined here.

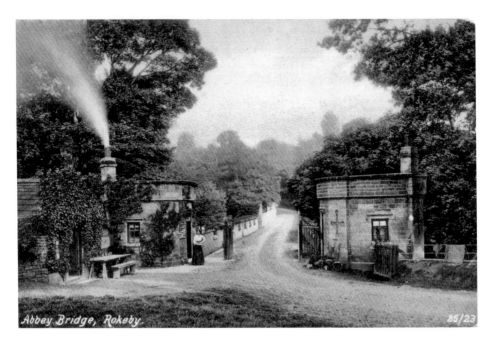

Abbey Bridge, Rokeby. 25/23

Abbey Bridge Tollgate

On the Yorkshire side, the toll cottage accommodation was divided in two: the living room was on the left and the bedroom on the right. Sadly, the cottages were demolished in 1958 after the last tenants left in 1956. In addition to exacting tolls the residents sold refreshments and postcards. Tolls were: pedestrians ½*d*, motor cars 6*d*, chaise with two horses 9*d*, gig 6*d*, wagon with three horses 10*d*, cattle 1*s* 3*d* for 20, sheep 8*d* per 20. Residents paid rent to the bridge owner and kept the toll money.

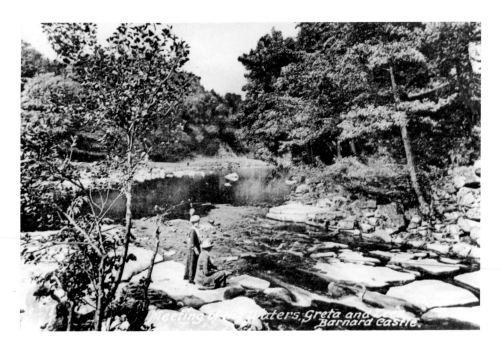

Greta Bridge

The 1773 bridge near here is, by common consent, one of the most picturesque in England and the area is the subject of countless paintings, the most famous of which are by John Sell Cotman (*Greta Bridge*), and Turner (*The Meeting of the Waters*) depicting the confluence of the Tees. Sir Walter Scott, a friend of Morritt's, stayed hereabouts on many occasions particularly when composing *Rokeby*. A cave on the river is named after him. Velazquez' *Rokeby Venus* was on display at Rokeby Hall from 1805 and 1905; it now hangs in the National Gallery.

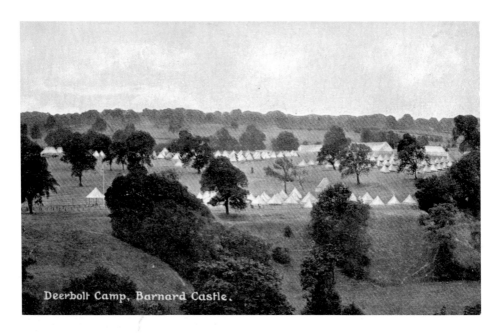

Deerbolt Camp, Barnard Castle.

Deerbolt Camp

This 1907 card shows the tents of the Militia on what was possibly their summer camp. The 17th Durham Light Infantry battalion was recruited and encamped here in 1915. Permanent (wooden) army buildings were established during the Second World War for the six regiments stationed here, including the tank-driving Royal Armoured Corps. John le Mesurier appeared in an army production here. Since 1973 it has been a Young Offenders' Institution. The modern picture shows the memorial to the RAF crew who died in the hills around Barnard Castle during the Second World War.

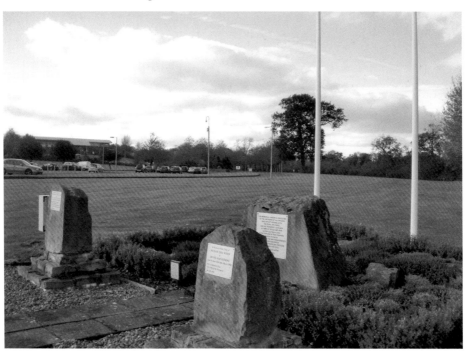

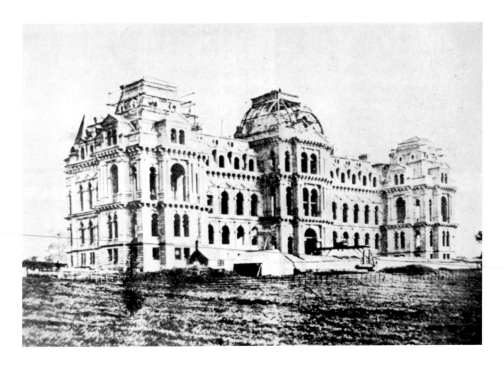

The (Josephine and John) Bowes Museum

This was under construction in 1869 to a design by architect Jules Pellechet and intended as a house and a place to house the Bowes' numerous antiquities. After the deaths of Josephine (French actress and Countess of Montalbo) in 1874 and John in 1885, the property was left to the public as a museum and park and opened in 1892. There is also an unfinished Roman Catholic chapel (see page 54). Montalbo is a town in Spain not far from Toledo.

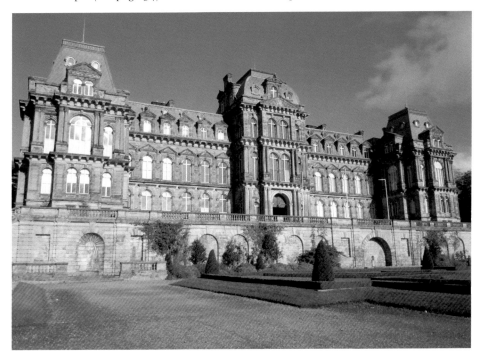

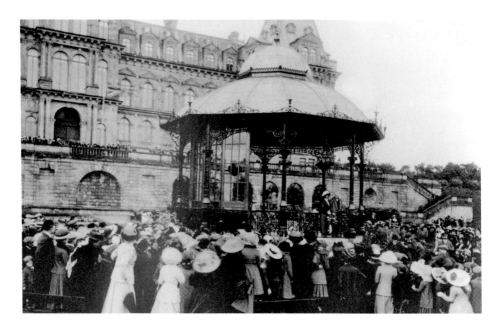

Bowes Museum Bandstand
The grand opening of the bandstand in 1912 by Lady Glamis, Countess of Strathmore, which replaced the ornamental lake. It featured wooden sliding doors and glass panels to protect players from the elements. The Hartlepool Military Band performed the honours on the day. Today the cast-iron bandstand is gone, removed in 1952 because it spoiled the audience's view of a production of *Merry England* and was replaced by... an ornamental lake.

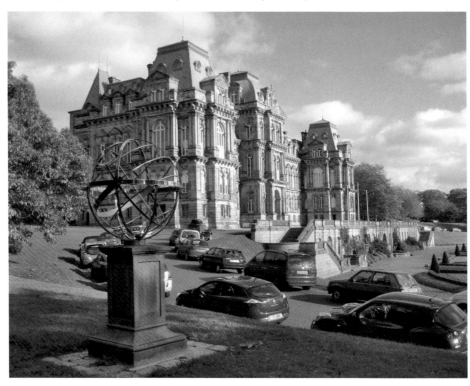

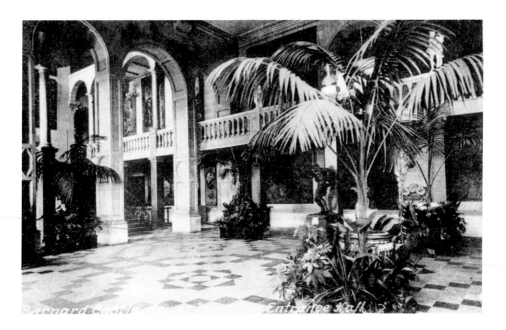

The Entrance Hall in 1933

Designed to evoke French chateaux (the Bowes also had a chateau at Louveciennes) the museum cost over £100,000, is 300 feet long and eighty-five feet high, and the central dome rises to 150 feet. The late Queen Mother, Elizabeth Bowes-Lyon, is related to John Bowes. Every country in Europe in the late nineteenth century is represented in his extensive collection. The contemporary photograph shows the splendid foyer today, which also features the famous automaton White Swan.

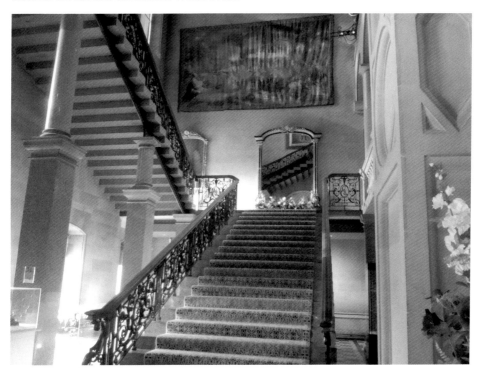

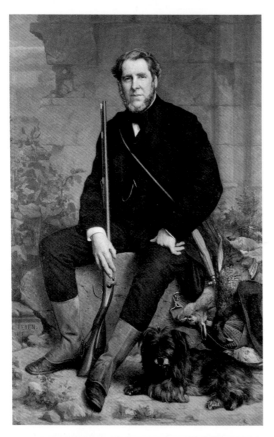

The Unfinished Chapel

The chapel was the wish of Josephine Bowes who had hoped to be buried there; however she died before the building was completed. Stones from the half-built chapel were used in 1926 in the construction of St Mary's Roman Catholic church on the corner of Newgate and Birch Road. The bodies of John and Josephine Bowes were reburied here, having initially been laid to rest at Gibside near Gateshead. The older picture is of John Bowes; the newer shows the splendid tapestry produced by children of Cotherstone School, which hangs in the foyer.

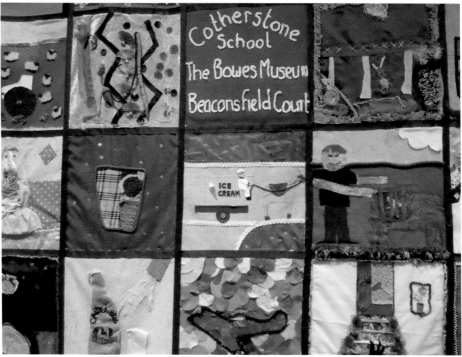

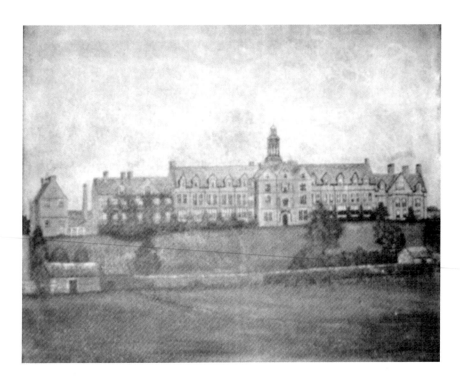

The North East County School
Originally called the North East County School, this English Gothic pile set in fifty acres was founded in 1883 and catered for up to 300 boarders and fifty day boys. It became Barnard Castle School in 1924. Before the main buildings were completed the school was temporarily housed at Middleton-One-Row, from which the old pavilion was transported and re-erected on the new site.

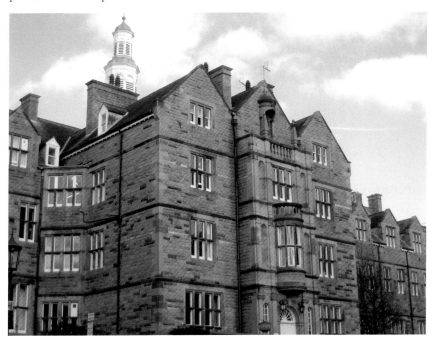

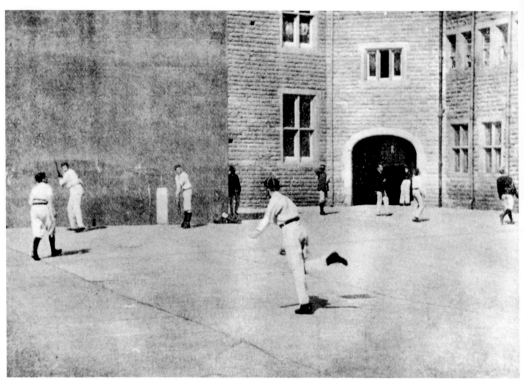

Boot Boys

As with many such schools, Barnard Castle was very much self-contained and had its own domestic staff including laundry, dormitory, kitchen and refectory maids, gardeners, porters, cleaners, cooks and two men who cleaned the boys' shoes and boots. The school also had its own bakery and baker, the Bakehouse. The school purchased its first computer in 1978; so large was it that it occupied its own room. Famous old boys include actor Kevin Whately, Geoffrey Smith, horiculturalist, Ian Carr, jazz musician and rugby internationals Rob Andrew, Matthew Tait and Rory and Tony Underwood.

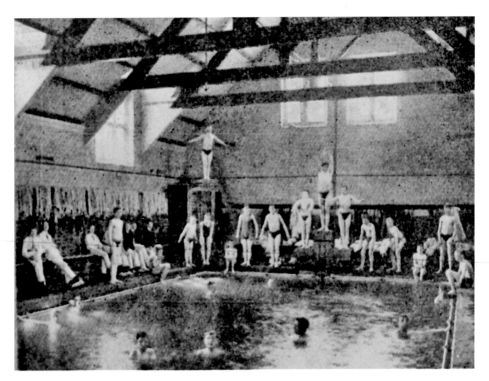

Crop Cultivation

The 1896 swimming baths are pictured here. Practical subjects have always been important at the school: agriculture was served by the Agricultural Plots, where pupils were taught crop cultivation with frequent visits to farms, agricultural shows and livestock markets. Engineering was also on the timetable. The National School in the town was established in 1814 in St Mary's churchyard; it educated up to 170 pupils at any one time and was demolished in 1896.

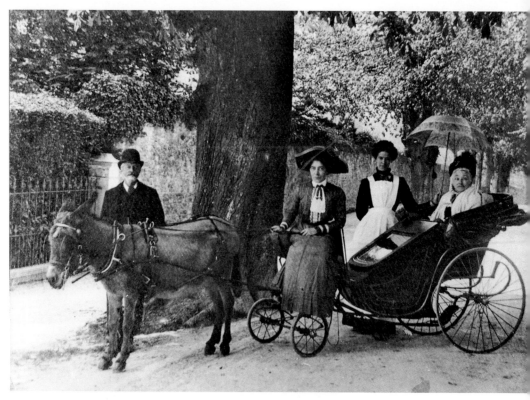

Enjoying Barnard Castle
This delightful picture shows a group of ladies enjoying an afternoon out in Barnard Castle around the turn of the century. The contemporary photograph shows that not much has changed two centuries later, although things may now be a little less formal.

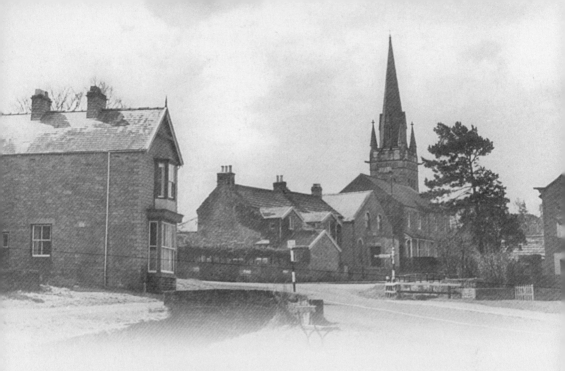

CHAPTER 2

Teesdale Villages

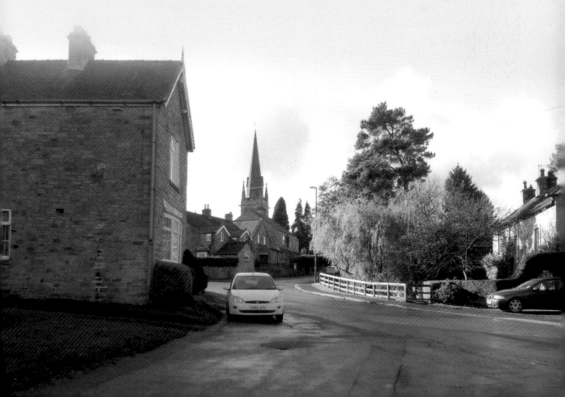

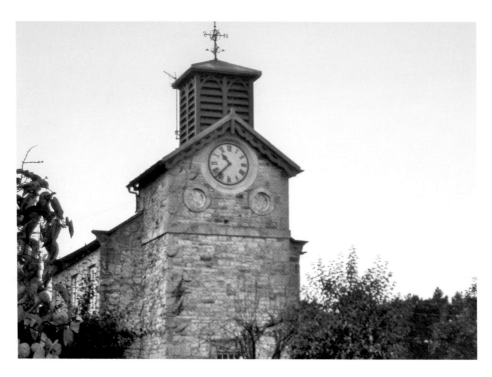

Lartington

The older photograph shows St Lawrence's church while the newer one is of mid-nineteenth-century Lartington schoolhouse cottage and tower, sporting wavy bargeboards. Both buildings have been converted into private residences. The centrepiece of the village is the 1635 sixteen-bedroom Lartington Hall whose gardens were designed by York architect Joseph Hansom of cab fame.

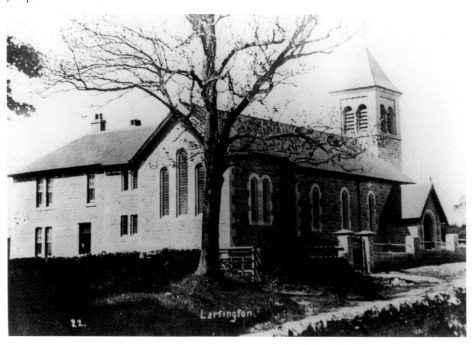

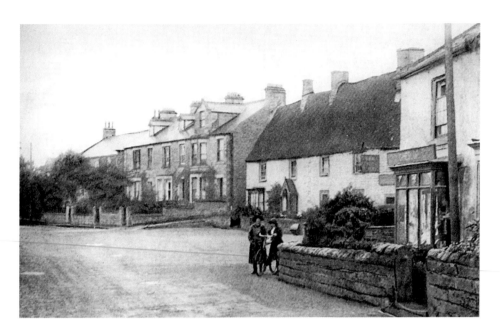

Cotherstone Red Lion

The swing bridge in Cotherstone was the scene of a tragic accident in 1929 when football supporters at a game between Mickleton and Cotherstone crowded onto the bridge; twenty-five of them fell the twenty-two feet into the river, and one Mrs Sally Nattrass later died. Cotherstone is famous for its cheese: its reputation goes back to 1858 and is based on a non-monastic form of Wensleydale originally made from ewes' milk. Hannah Hauxwell farmed nearby at Low Birk Hatt Farm and moved in to the village itself in 1998.

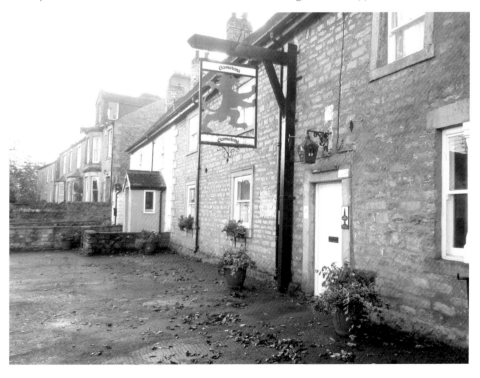

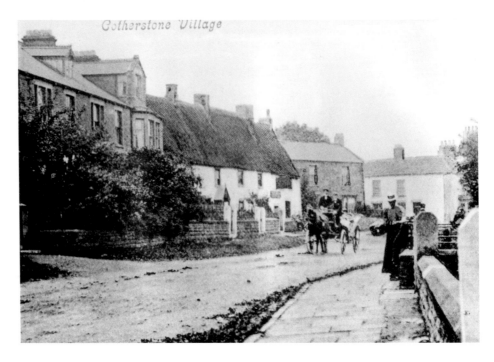

Red Lion Cotherston

Same view as the previous page but looking the other way. The Cameron's pub and the post office on the right are pictured around 1925. The thatched roof on the pub was replaced in 1935 and the post office has moved further down the street. The pictures on page 59 show St Cuthbert's church, and next door is the village hall built in 1883 as a Temperance Hall. The spire on the church is not the original; it was replaced in 1915. The spelling of the station was changed to Cotherston in 1906, reverting back to Cotherstone 1914.

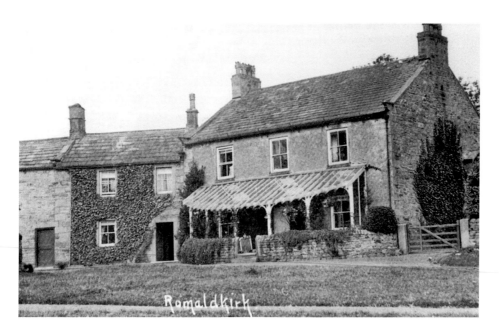

High Green House, Romaldkirk

High Green House in Fell Lane, where the external canopy survives to this day. The house to the left is Rose Cottage – probably once the village bakery if the cylindrical oven just visible is anything to go by. Romaldkirk is unusual in that it is blessed with three village greens. *Baine's 1823 Directory of Professions and Trades* sums up life in the village: there was a doctor, five farmers, three masons, two shoemakers, three shopkeepers and one butcher, two weavers, a blacksmith and three wheelwrights, and a common carrier.

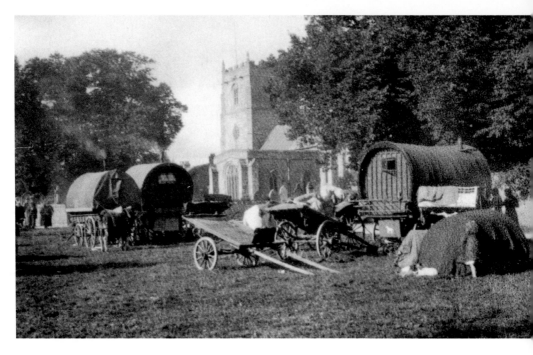

Romaldkirk Fair

Romaldkirk Fair around 1910 with a Romany contingent no doubt involved in some horse trading. The fair was held twice a year in April and October until 1930 when 'inappropriate behaviour' brought it to an end. The modern picture shows the stunning window in the south transept of the church.

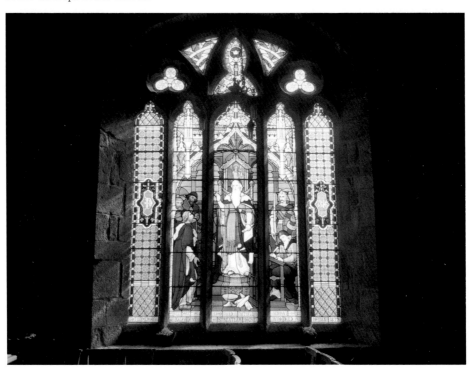

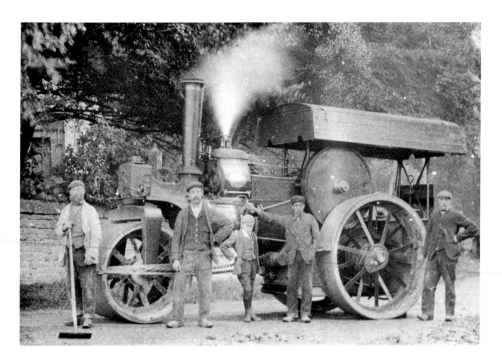

St Romald's Church

Middle Green or Monk's Square. A twelfth-century cruciform church, St Romald's, was the church for England's largest parish, extending from Barnard Castle into Lunedale. In 1644 the plague claimed a third of the parishioners, and they were buried down by the river. In 1870 there was much (decidedly un-Christian) controversy surrounding restoration of churches in the neighbourhood as reported in the *Teesdale Mercury*: 'conceited mischievous, meddlesome country parsons who in the sublime audacity of a dense ignorance, sanction... the destruction of objects they are legally bound to protect'.

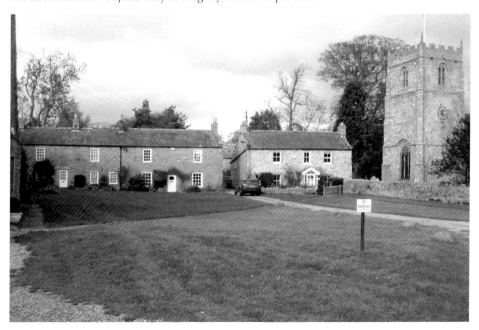

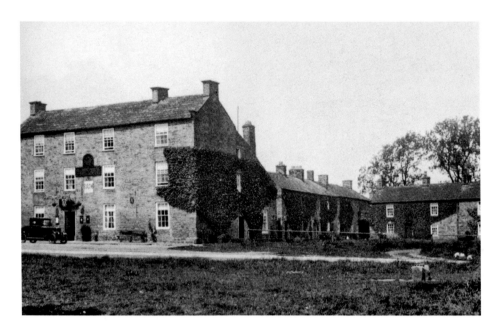

Stocks, Pumps and the Pound

A 1933 photograph showing the Rose & Crown and the Square to the right. There was a grocer's shop at the end of the row of cottages. The other public house in the village today is the Kirk Inn (see page 68); however, in around 1910 there were no fewer than five drinking establishments; the King's Arms opposite the Kirk, the Bluebell and the Mason's Arms have since gone. The stocks are still there though and the pump is one of two that served the village – one dating from 1886. The pound is also still visible. Grace Scott survived the plague by building a mud hut a mile from the village, and lived there until the risk of infection was over. A farm was built on the site, which is still called Gracie's Cottage.

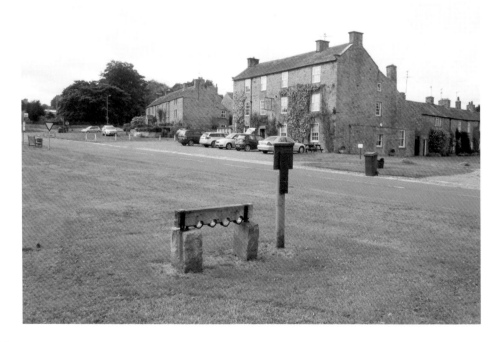

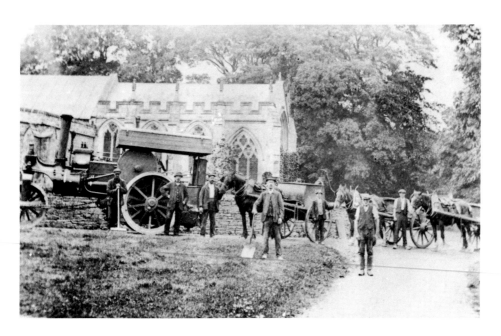

Saint Rumwald of Brackley

Romaldkirk is reputedly named after Saint Rumwald of Brackley, sometimes called Rumwold or Rumbald of Buckingham, born AD 650; the grandson of King Penda of Mercia, and the son of a Pagan prince of Northumbria. Various legends surround him including one which has it that at three days old the prince at his baptism said the creed out loud, preached a sermon on the Holy Trinity and the need for virtuous living... and then promptly died. There is still a well dedicated to Saint Rumwald at Alstrop, Northamptonshire. He is patron saint of Buckingham (part of Buckingham Parish Church is dedicated to him) and of fishermen at Folkestone.

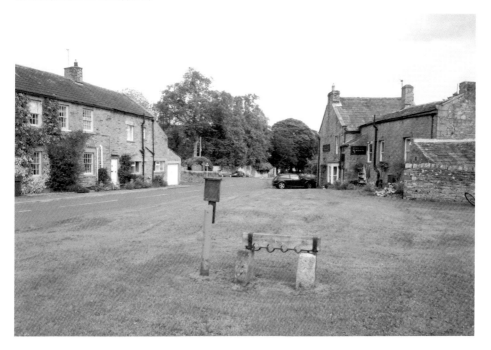

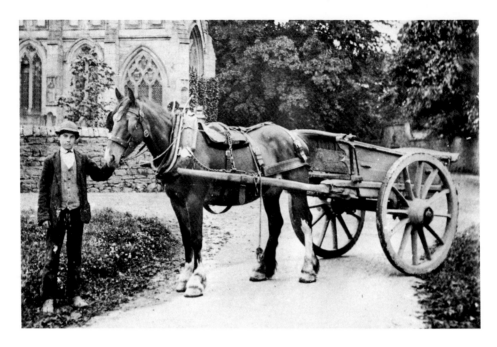

The 'Cathedral of the Dale'

The present church, often popularly elevated to Cathedral status, largely replaces a white plaster walled Saxon predecessor sacked by the Vikings. Pre-Norman elements can be seen at the base of the chancel arch. Rebuilding began about 1155 and continued into the sixteenth century. The Domesday Book tells us, 'There is in Romoldscherce one carucate of land of the geld and there may have been two ploughs. Torfin held it, now Bodin holds it and it is waste'. The devastation was a result of the Harrying of the North, William I's scorched-earth campaign to subdue the rebellious north.

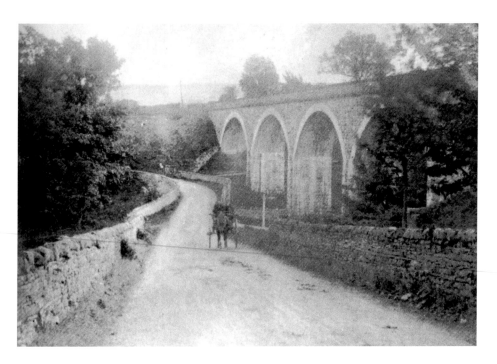

Lune Bridge, Mickleton

This card is from around 1905 and shows the Lune Bridge towering over the road. It carries the Tees Valley Railway branch line from Barnard Castle to Middleton over the River Lune. Mickleton station on Bail Hill was opened in May 1868, closed in 1964 and subsequently demolished.

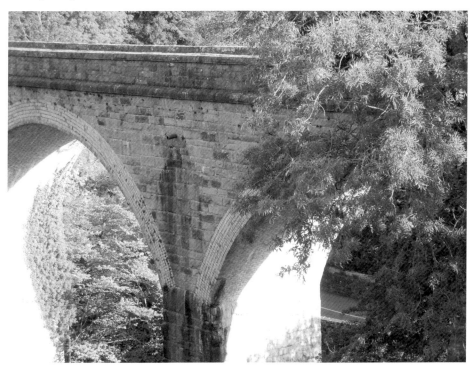

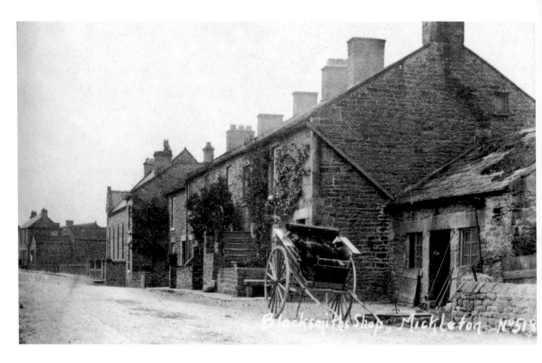

Blacksmiths Shop, Mickleton. No 518

Blacksmiths Arms

The blacksmith's here in 1911 has been replaced by the Blacksmiths Arms. Lady Rake Mine at Harwood boasted the highest output of silver in the UK at one time.

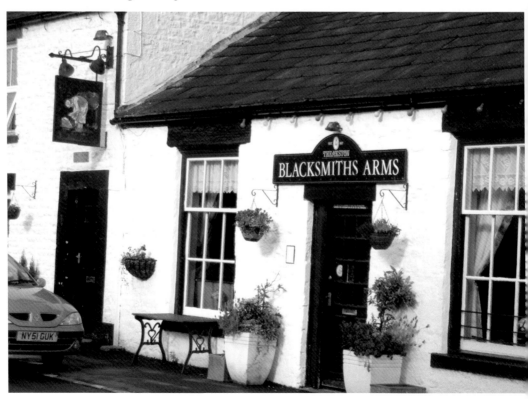

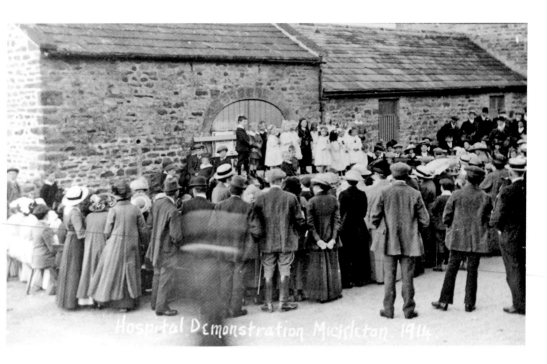

Hospital Demonstration Mickleton. 1914

Mickleton Hospital Demonstration

Hospital demonstrations were fund-raising events for local hospitals. Mickleton was notable for having two Methodist chapels and a mission church, the nearest church of England being at Laithkirk. The Bronze Age burial site of Kirkcarrion looms on the hills behind the village.

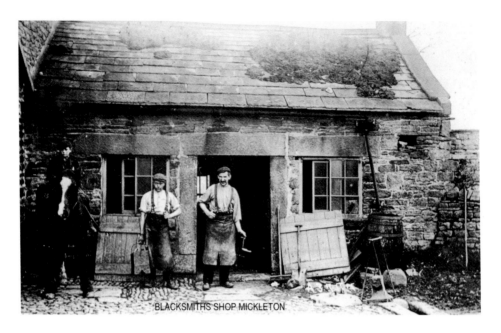

BLACKSMITHS SHOP MICKLETON

Lead Mining

Lead mining was an important local industry from around 1770, with mines at nearby Eggleston (Blackton lead mills) owned by the London Lead Company. The railways replaced horses in 1867, importing coal and exporting lead and the silver in the ore. The works were closed in 1904 one year before the company ceased trading. Quebec Terrace in Mickleton is so-called because it was built on the site of the General Wolfe public house.

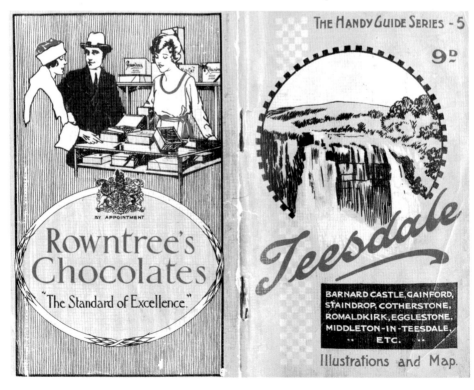

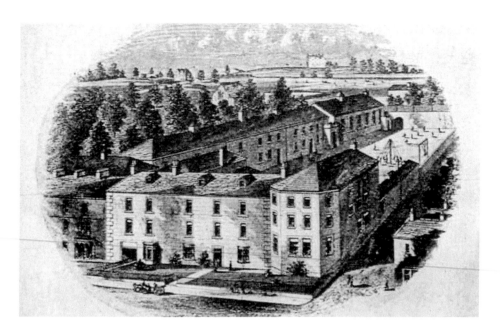

Gainford Academy and Stan Laurel

Or Bowman's Academy, which thrived from 1819 to 1899. Its most illustrious old boy was Arthur Stanley Jefferson, better known as Stan Laurel, who was here from 1903. It was restored in 1987 and is home to the Gainford Drama Club at the Academy Theatre, High Green. The new picture shows the dilapidated St Peter's Catholic Orphanage Diocesan Certified School for Boys, which opened in 1900. It was requisitioned in 1937 for Basque refugees who had fled their homeland during the Spanish Civil War.

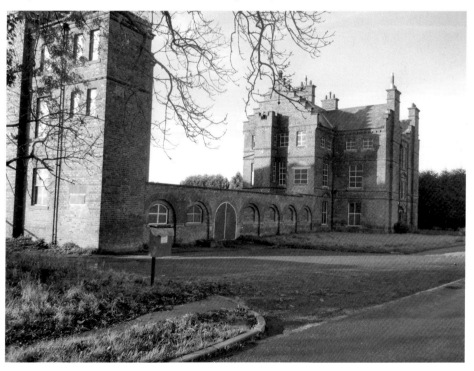

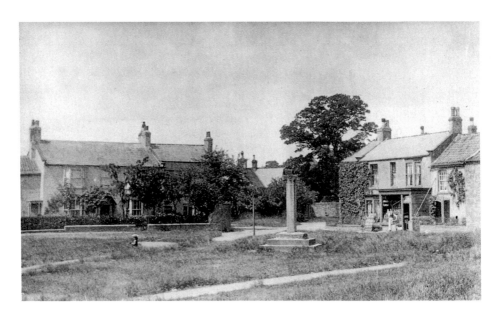

Gainford and the Bishop of Lindisfarne

The twelve-foot cross commemorates Victoria's Diamond Jubilee in 1897 at a ceremony in 1899 led by Lord Barnard, and its base is formed of an ancient cross excavated here. The church in the background, St Mary the Virgin, was built on the site of ninth-century church established by Egred, Bishop of Lindisfarne, and given to the monks of St Cuthbert. Amongst the liberties enjoyed by the parish were right of execution, and confiscation of goods of felons. The church recently won fame when the vicar married a Pigg, christened a Lamb and buried a Hogg all in the same week.

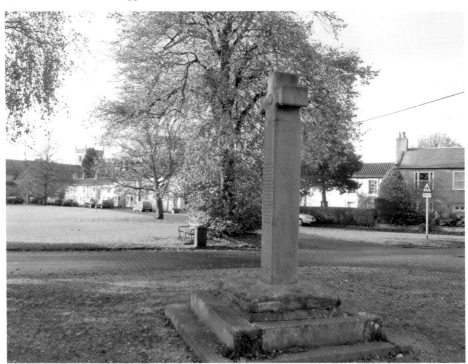

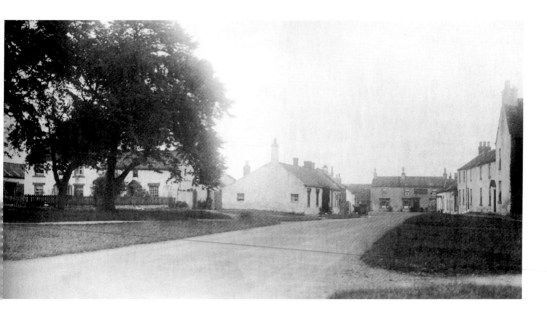

Magae

The pub at the end of the road is the Carlbury, formerly the Wheatsheaf. A Roman fort stood here at what was called 'Magae' to guard this strategic crossing of the Tees. The fort was connected to Dere Street and incorporated two bridges over the river from the second or third centuries, although controversy surrounds this. The first, made of wood, was washed away when the course of the river changed. The second was uncovered during quarrying in 1972; it was also built of wood but was supported by stone abutments and five masonry piers.

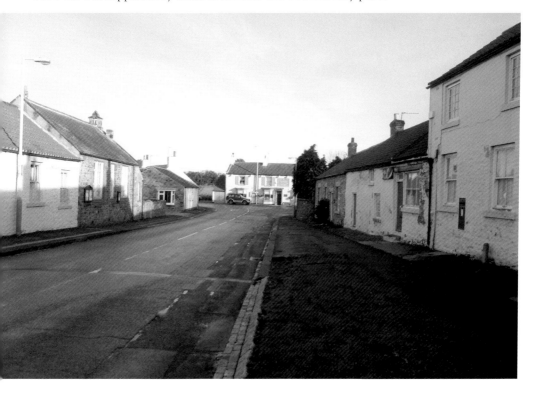

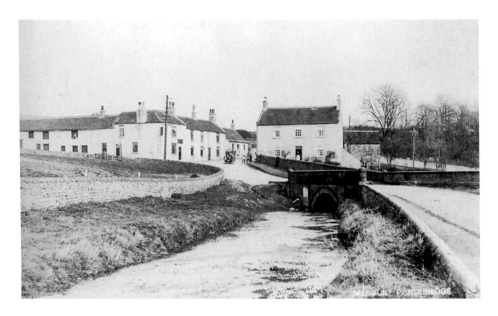

Carlbury

A civilian settlement developed around the fort on both sides of the river and was linked by the bridge. Roman buildings, including a barracks block and a bathhouse, were uncovered by excavations in the 1970s. Carlbury is the area of the village to the north of Dyance Beck here (also called Piercebridge Beck). The Railway Inn on the left was sacrificed to the bypass. The George in Piercebridge is famous for the clock that inspired American composer Henry Clay Work to write his famous *My Grandfather's Clock* when he visited in 1878. All long case clocks were henceforth called 'grandfather' clocks. The clock stopped at the precise moment of its owner's death and never ticked again.

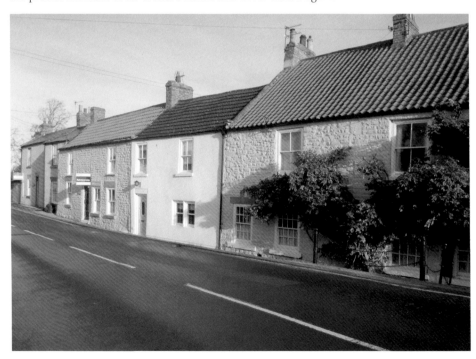

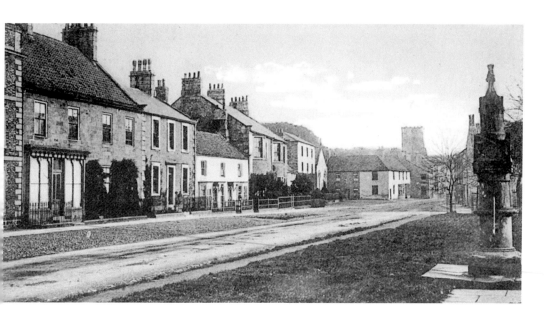

Staindrop Village Pump

The village pump just off Front Street was installed in 1865 as a memorial to Henry, 2nd Duke of Cleveland, and Lady Sophia Poulett, his wife. Front Street is almost half a mile long widening out at the western end to form the green. Records for the village date back to 1031, when it was given to the monks of Durham Cathedral by King Cnut. In 1050 it is called 'Standropa', and, in Old English, 'Saen-throp', which translates to stony village.

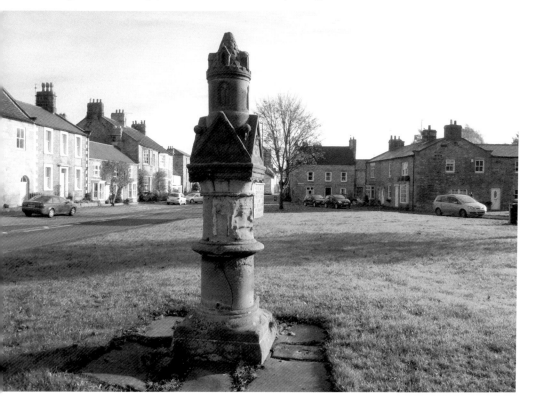

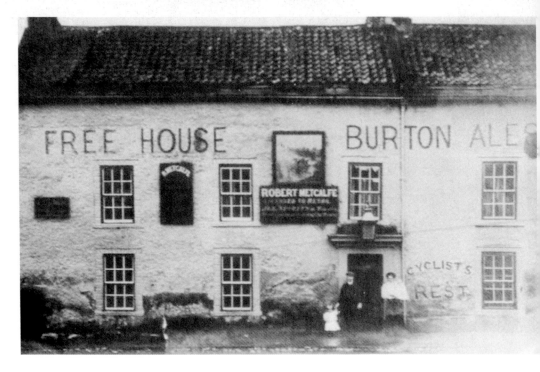

The Black Swan, Staindrop

A shot from the turn of the twentieth century, of the Black Swan, promoting itself as the 'cyclists' rest'. One of the other locals at the time was the Wheatsheaf Inn although in 1856 the village had no fewer than nine pubs. Staindrop was one of the seven settlements which constituted the County Palatinate of Durham until 1796.

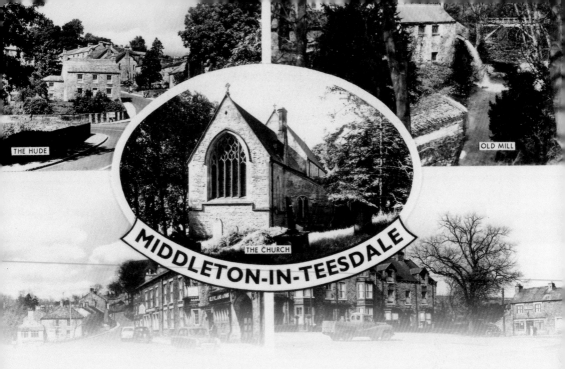

CHAPTER 3

Middleton-in-Teesdale

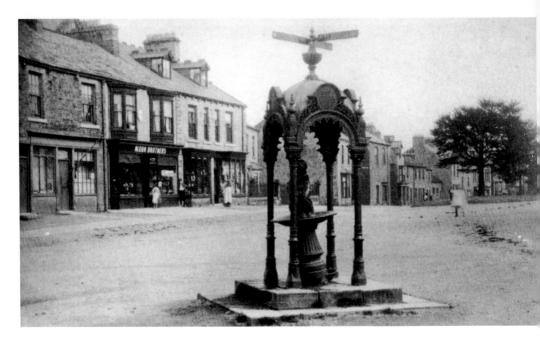

The Company for Smelting Down Lead with Pitcoal

The London Lead Company bought a sizeable part of the town in 1815. The drinking fountain-cum-road sign here was put up by a R. W. Bainbridge in 1877 to mark a testimonial he received from the London Lead Company. The company was incorporated by Royal Charter in 1692; its correct name was The Company for Smelting Down Lead with Pitcoal.

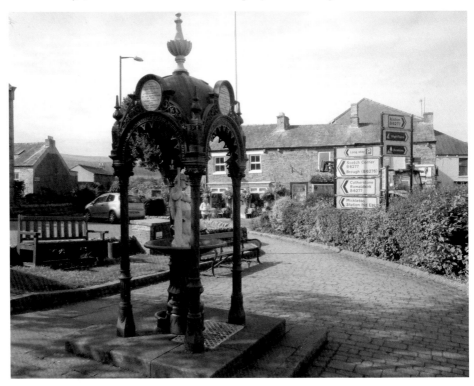

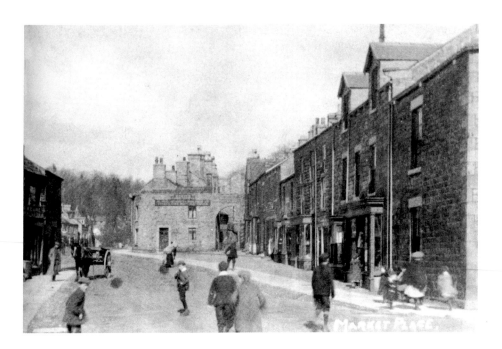

Market Place

The importance of lead mining to Middleton is reflected in the parish registers: for example, in 1837, of the 113 baptisms, 83 (73 per cent) were of infants whose fathers were in the mining or smelting industries. By 1900, however, it was virtually all over. The price of lead had fallen like the proverbial lead balloon and there was intense competition from Spanish imports and from other materials. The Company was wound up in 1905, selling the mines to the Vieille Montagne Company who mined them for zinc up until the Second World War. The building in the background is now the Tourist Information Office.

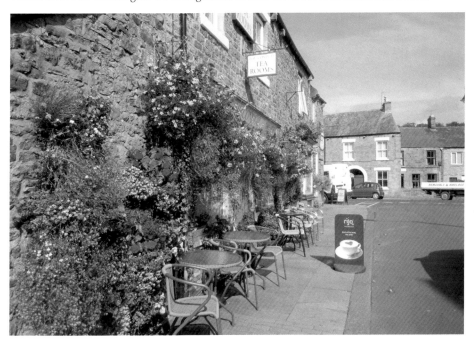

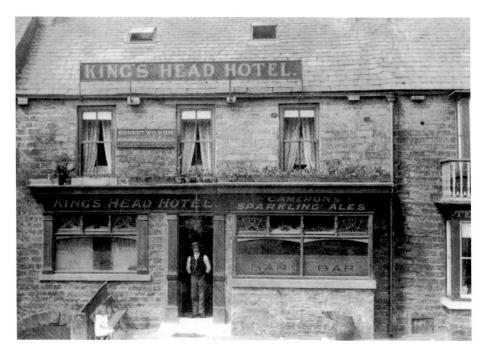

The King's Head

Taken around 1914, this shows the pub to have been a Cameron's house run by Robert Wilson. Cameron's were a West Hartlepool brewery noted then it seems, for its 'sparkling ales', but more recently it is famous for Strongarm, its ruby red ale. Today, the King's Head and the old Forresters pub next door combine to make the Forresters Hotel and Restaurant.

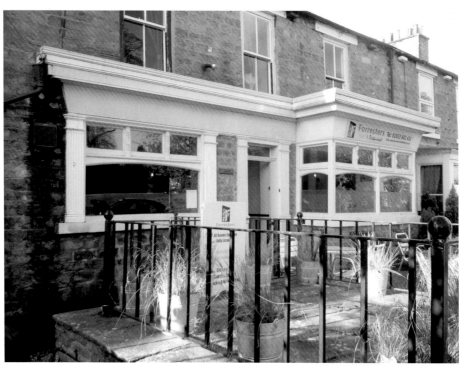

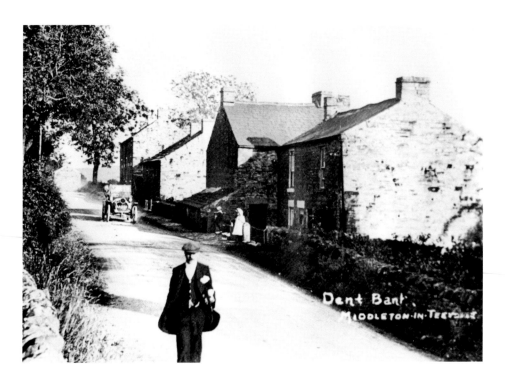

Dent Bank

This is about half a mile to the north-west on the Newbiggin Road. The modern picture is looking down Hude towards the town. The London Lead Company had started operating in Teesdale in 1753 when it leased a mine at Newbiggin in Teesdale and then a smelting mill at Eggleston. It moved its headquarters to Middleton in 1815 where it built Middleton House.

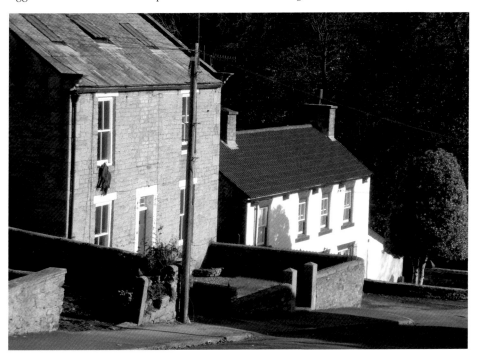

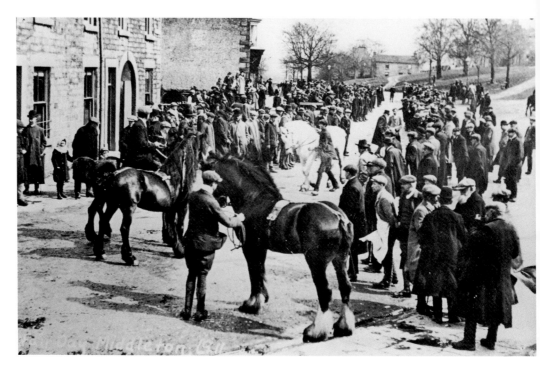

Middleton Fair Day, 1909
Fair Day, 1909, and the all-important business of horse trading in Horse Market. The contemporary photograph shows one of the striking wall paintings in the yard of the Teesdale Hotel on Market Place.

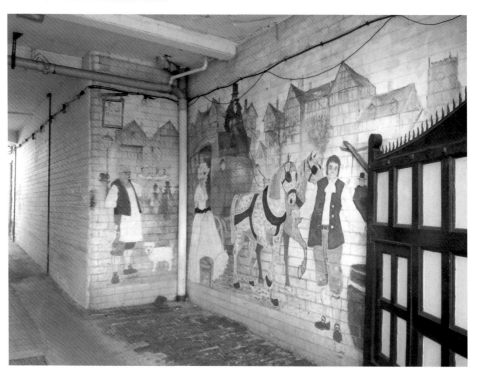

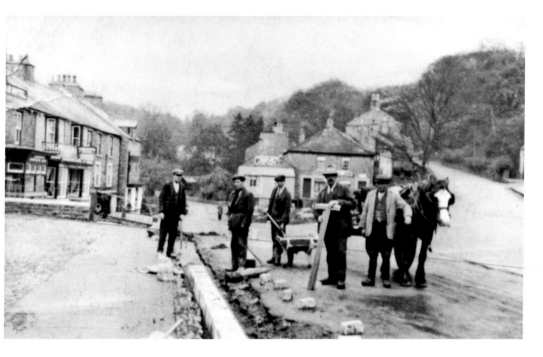

Road Workers in Market Place

The Forresters Arms and King's Head can be seen in the background. When the railways came to the dale they brought opportunities for tourism and excursions – in both directions. One in July 1867 sent 600 dales people to Sunderland for a day out; those from Middleton had to leave at 3.00 a.m. to get to Barnard Castle station in time.

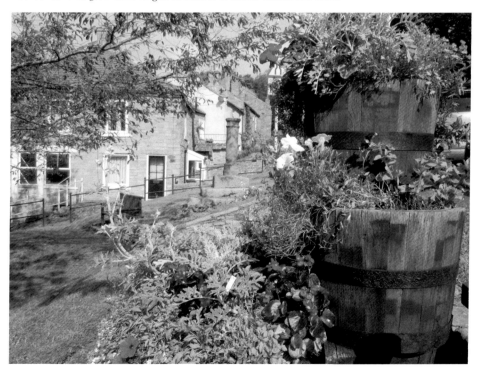

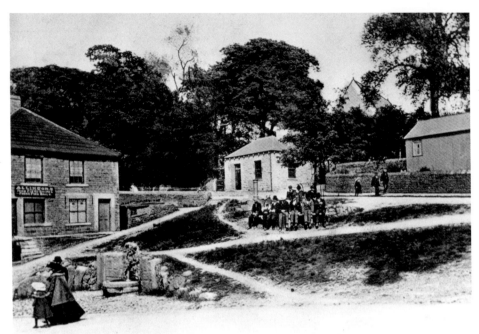

MIDDLETON IN TEESDALE.

Seed Hill
The photographs are looking towards St Mary the Virgin church (see also page 92). Allinson's fish and chip shop ('Fresh Fish Daily') is the building in the background of the older picture. The old well has been preserved.

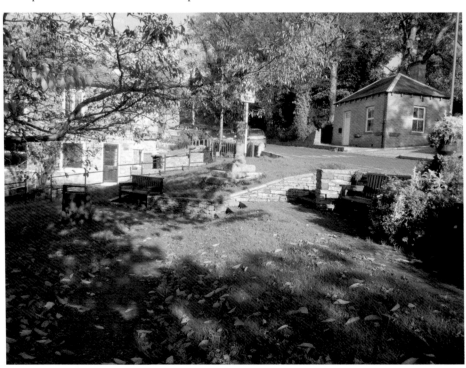

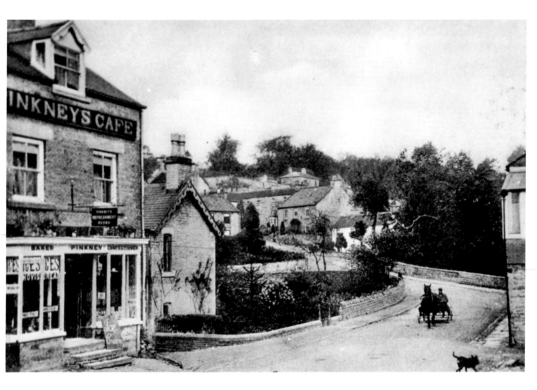

Pinkney's Café
There was a watermill behind the café. The bridge is called Hude Bridge or the Rose & Crown Bridge after the pub that stood here in Rose Terrace – now a workingmen's club.

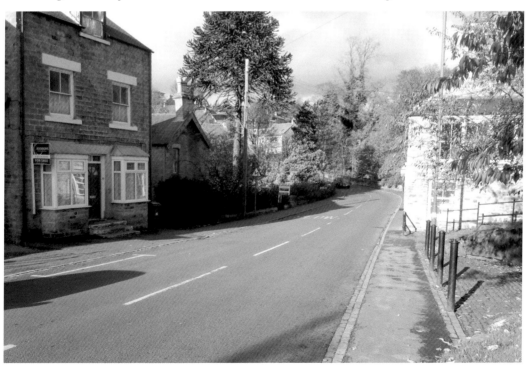

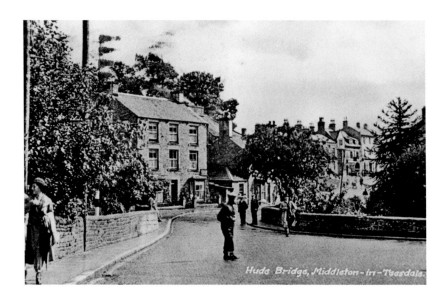

Hude Bridge

The modern picture shows the impressive campanile that formed part of the London Lead Company's headquarters building. In common with other Quaker companies they did much to try and improve the home and working life of its employees, for example, they built company houses in what became known as Newtown described in a contemporary report as follows: 'Masterman Place or as it is sometimes called, New-Middleton, was erected in 1833 by the London Lead Company from the chaste and appropriate design of Mr. Bonomi and...consists of several uniform rows of neat and convenient cottages, situated in a spacious garden, a portion of which was appropriated to each dwelling... as vacancies occur, they place their most deserving workmen, thus combining general utility with the reward of personal merit. The first occupiers took possession of their new abodes in May 1824, accompanied by bands of music, etc'. Temperance was imposed by the company as a precondition of occupation.

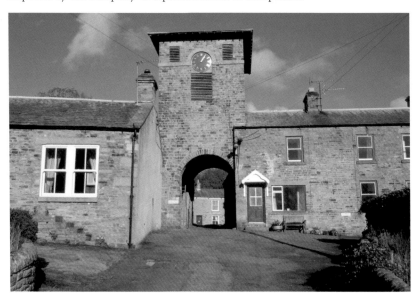

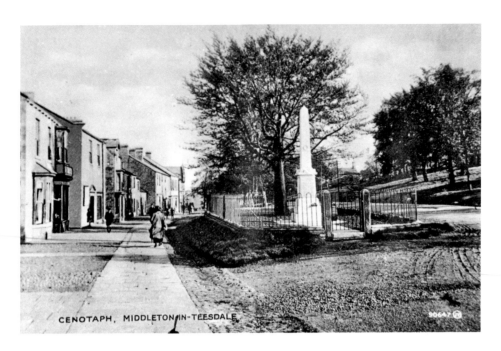

CENOTAPH, MIDDLETON-IN-TEESDALE

The Cenotaph

Here is the town's cenotaph in Horse Market. The houses in Masterman Place were built and occupied on a strictly hierarchical basis: Ten Row (now River Terrace) and New Town Terrace had one-up-one-down cottages for miners with a long, narrow garden and a pigsty. Skilled workers had larger cottages while under-managers, surveyors and the doctor had far superior houses.

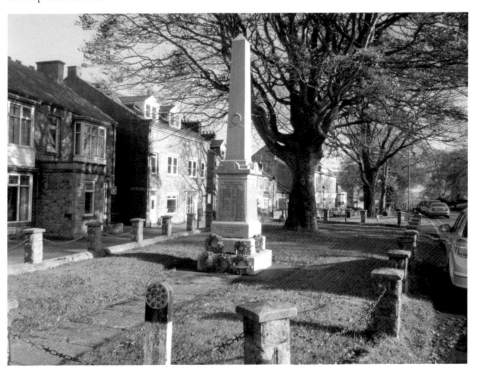

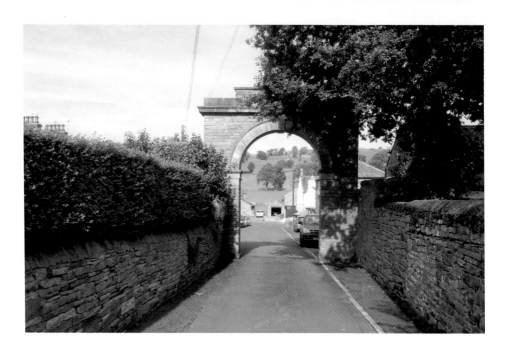

Hospital Demonstration

Middleton's money raising event in the 1920s passing the Wesleyan Chapel in Horse Market; the banner reads 'Canadian Pacific'. The modern picture shows the imposing archway leading into Masterman Place and New Town built by the Quaker London Lead Company for its miners. The building next to the arch was the company sponsored workers' library. The arch was gated and locked at night to keep residents in and on the straight and narrow. London Lead was the first British company to introduce the five-day working week.

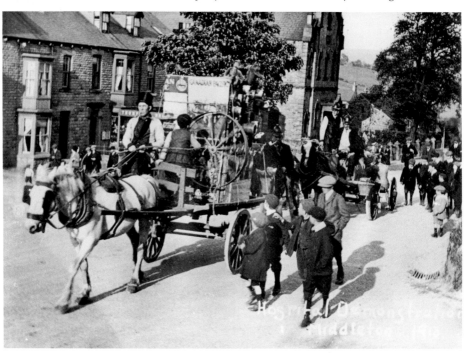

25-26 Market Place, Middleton-in-Teesdale
Telephone 406

Quality Ironmongery and Hardware

Camping-Gaz, Aladdin and Valor Heaters.
Fishing—Rods, Line, Casts, Reels & Flies
Fishing Licences issued. Permits for Fishing
on the Yorkshire side of the Tees.

TOOLS——for the Craftsman,
for the Handiman, for the Gardener
including Fertilizers, Compost, Weedkiller.

— F A N C Y G O O D S —
in China, Glass, Pewter, Brassware, Mirrors

KITCHEN WARE and UTENSILS—
Pyrex, Non-Stick Pans, Plastics, Pails, Brushes
FOR HOUSE DECORATION—
Paints : Dulux, Crown, Japlac, Mangers

ELECTRICAL GOODS - ALL FITTINGS
CYCLE REQUISITES

J. Raine & Sons Ironmongers
Nothing much has changed at Raine's
in the thirty years or so since their
advertisement appeared in *A Guide to
Middleton in Teesdale* in the 1970s. Note
the gobstopper machines to the left of
the door on the modern photograph.

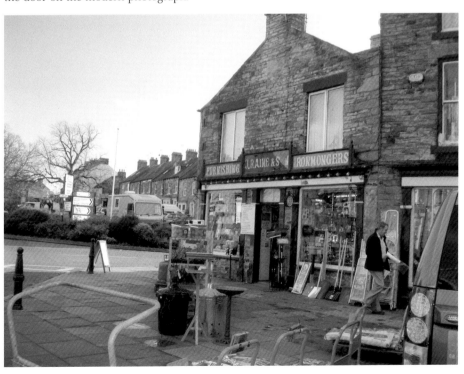

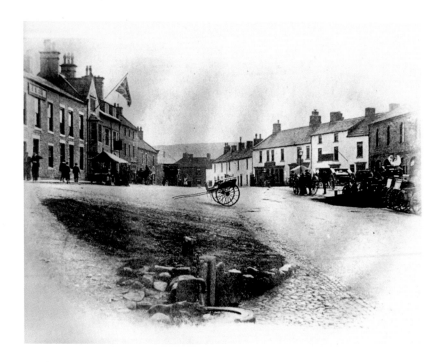

Market Place

From Seed Hill with Mechanics' Institute, financed by the London Lead Company, on the right, which incorporated a library and reading room. There were regular lectures on gardening and smallholding and seeds were sold to encourage gardening. The three-storey white building is Joseph Bell – decorator, plumber and lighting contractor. The Blue Bell is on the left (see page 94). The well can be seen in the foreground (see page 86). The modern picture shows the village pump on Seed Hill with St Mary the Virgin church in the background.

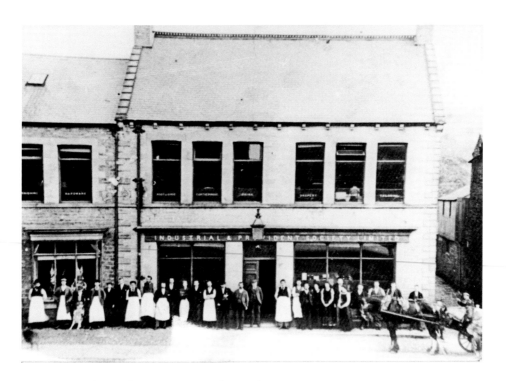

Middleton Industrial & Provident Society Ltd

Predating the 1844 formation of the Co-operative Society in Rochdale, the Governor & Company's Teesdale Workmen's Corn Association was set up by miners and the London Lead Company in 1842. The name was changed to the Teesdale Workmen's Industrial & Provident Society, at which point a grocer's was opened. Grain was milled in the building near Hudeshope Beck and sold to the townsfolk, helping to keep the price of bread down. In 1873, the Co-operative bought this building in Horse Market to provide groceries, drapery, shoes and seeds, and a blacksmith's, butcher's and coal depot followed.

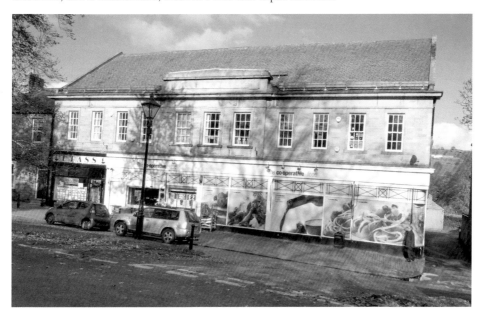

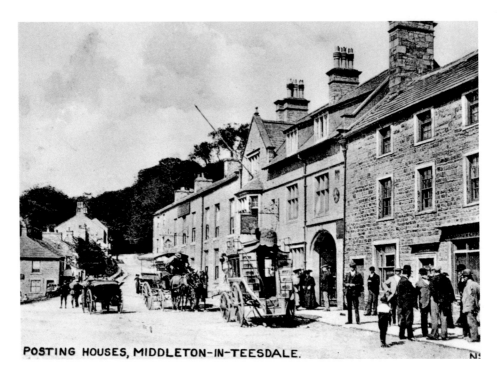

POSTING HOUSES, MIDDLETON-IN-TEESDALE.

Posting Houses

The Blue Bell and the eighteenth-century posting house, the Cleveland Arms Hotel and Assembly Rooms; the former is now a bed and breakfast, the latter still exists as the Teesdale Hotel. It was originally the Cross Keys until 1890.

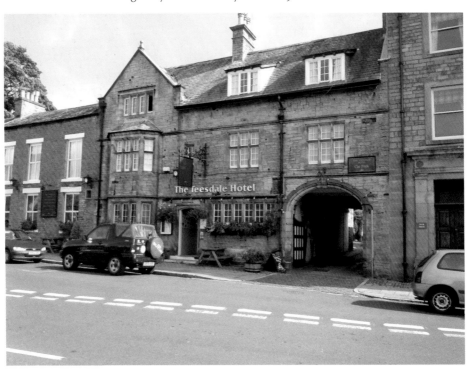

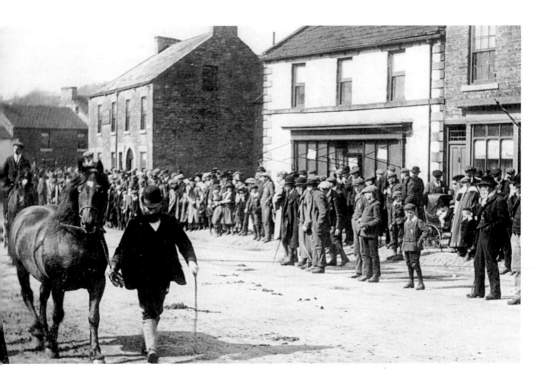

Whit Monday Procession of Horses

From around 1908, Whit Monday was always celebrated in style with horse processions and pierrots. The new picture was taken at one of Middleton's Tuesday cattle markets in November 2011.

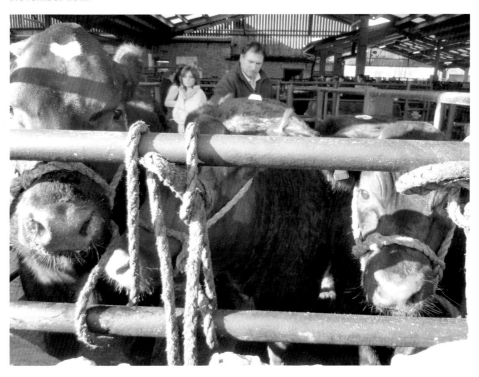

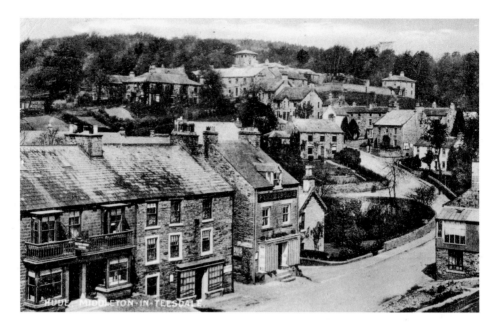

Hude

Or 'hood' – a natural protection against the winds blowing in from the surrounding hills. George Pinkney's café is there on the left – now a house. The corn mill is on Hudeshope Beck and the Rose & Crown Hotel halfway up the hill on the left. Middleton House is at the top of the hill – the headquarters of the London Lead Company – with the campanile clock tower further along the street (see page 88). The works' superintendent lived in the house as well as it being the company's head office. The complex of buildings included stores and a workshop repair centre for mine machinery.

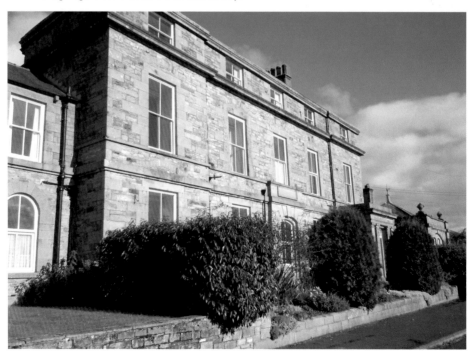